FUCK YEAH
MENSWEAR

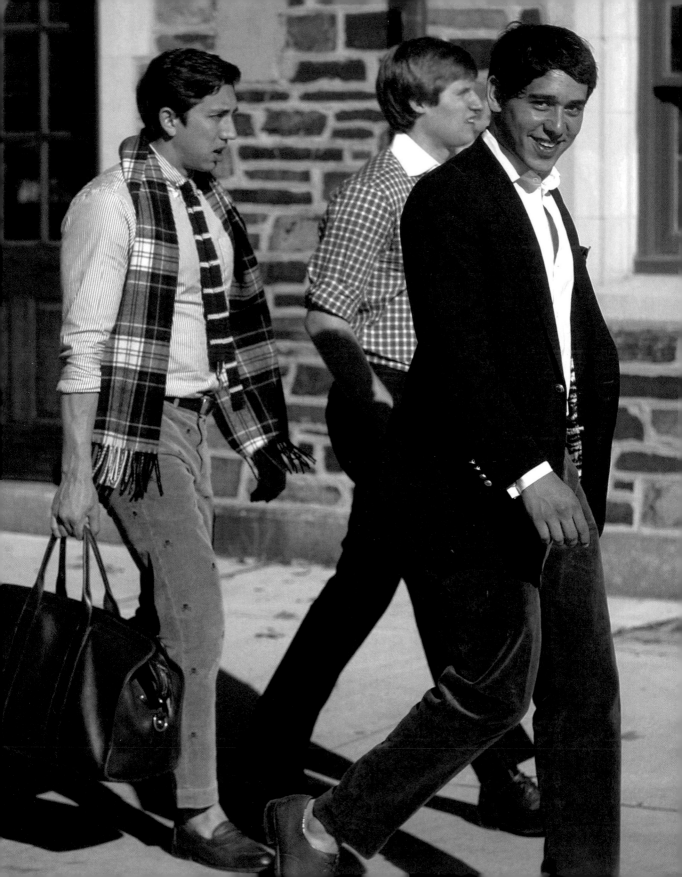

FUCK YEAH MENSWEAR

Bespoke Knowledge *for the* Crispy Gentleman

The EDITORS *of* ΓYMW

A Touchstone Book

Published by Simon & Schuster

New York London Toronto Sydney New Delhi

Touchstone
A Division of Simon & Schuster, Inc.
1230 Avenue of the Americas
New York, NY 10020

First Touchstone trade paperback edition November 2012

TOUCHSTONE and colophon are registered trademarks of Simon & Schuster, Inc.

For information about special discounts for bulk purchases, please contact
Simon & Schuster Special Sales at 1-866-506-1949 or business@simonandschuster.com.

The Simon & Schuster Speakers Bureau can bring authors to your live event.
For more information or to book an event, contact the Simon & Schuster Speakers Bureau
at 1-866-248-3049 or visit our website at www.simonspeakers.com.

Designed by Timothy Shaner

Manufactured in the United States of America

3 5 7 9 10 8 6 4

Library of Congress Cataloging-in-Publication Data

Fuck yeah menswear / by the editors of Fuck Yeah Menswear. —1st Touchstone trade paperback ed.
 p. cm.
Summary: Collection of anonymous blogs on men's fashion.
 1. Men's clothing—Blogs. 2. Men's clothing—Humor. I. Fuck yeah menswear (Online)
TT617.F83 2012
646'.3207—dc23

2012020895

ISBN 978-1-4516-7268-8
ISBN 978-1-4516-7269-5 (ebook)

PHOTO CREDITS:
Justin Chung (justinchungphotography.com): viii, 2, 6, 11, 17, 18, 36, 39, 46–47, 53–56, 63,
78–101, 108, 111, 134, 140, 144–146, 157, 176, 190, 212, 219–221, 231–243; **Ben Lamb:** 244;
Sergei Sviatchenko: xi, 12–13, 42–43, 64–65, 70–71, 116, 138–139, 148–149, 166–167, 180–181;
CLOSE UP AND PRIVATE is an ongoing project by artist Sergei Sviatchenko which looks to capture
the spirit of modern style, as seen through the subtle shades of the individual. The Editors of FYMW
are grateful for the use of original photos from the CUAP project—closeupandprivate.com; **Heather
Clawson:** 48–49, 50–51; **Stefán Kjartansson:** 127; **Ovadia & Sons:** 160, 216–217; **Gordon von
Steiner:** ii, 210; **Dominick Volini/Baron Wells:** 60–61; **Unionmade:** xii–1; **Tommy Ton:** 192; **All
other photos courtesy of Kevin Burrows.**

CONTENTS

p. 4

p. 53

p. 76

p.146

p. 166

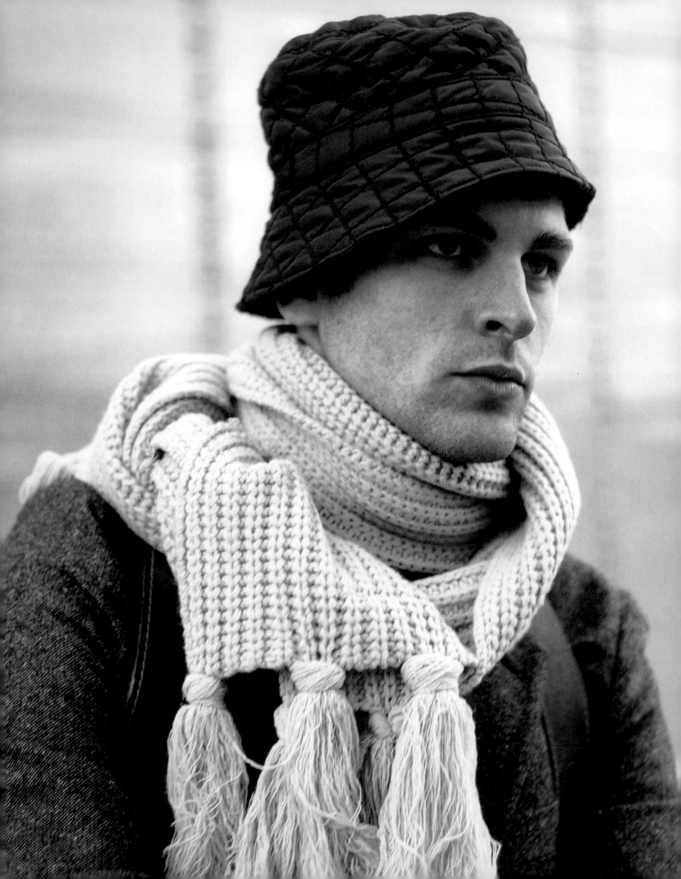

FYMW
Staff

CO-EDITORS IN CHIEF *Kevin Burrows & Lawrence Schlossman*

COGGI SWEATER STEAMER-AT-LARGE *Lauren Bailey*

GAME DE-STRESSER *George Von Strugglehousen*

PITTI UOMO STREET STYLE REBLOG AGENT *Thomas Grant*

DESIGNATED SHOULDER DUSTER *Peter Thoms*

GARMENT BAG HANDLER *Shelly Hopper*

SHOE POLISH TASTE TESTER *Nancy Upbright*

INTERNATIONAL ON LOCATION MULTIMEDIA
ONLINE CORRESPONDENT *That blogger, we think his name is Steve*

PUBLICIST *Chloe Strauss*

BAD PRESS PUBLICIST *Jill Marshall-Sanderson*

JAPANESE MAGAZINE TRANSLATOR *Takahari Takahishi*

WOMENSWEAR MOLE *Stefan Feathers*

VELVET ROPE LIAISON *Carter "C-Town AKA C-Money*
. *AKA The Stain" Bridges*

HUMBLEBRAG ENGINEER *Jason "Don't You Hate It When" Slater*

SOMMELIER *Karl Masterson ESQ. III*

SCARF ARCHITECT *Victor Richards*

RAP LYRIC DECODER *Young Stanley*

TROUSER BREAK ANALYST *Walter Stevenson*

POCKET SQUARE MANIPULATOR *Thadeus Wilde*

HEAD OF '80s GUCCI ARCHIVE *Franco Massiato*

HATER CONTENT MANAGEMENT *Joseph Quint*

SWAG RESEARCH AND DEVELOPMENT *Frank Winston*

HAIR TECHNICIAN / FADE ENGINEER *Frank, the Barber*

SENIOR SAMPLE SALE INTERMEDIARY *Michael R. Lewis*

HOOD PASS CONSULTANT *"Free Trillaveli!"*

OG-EDITOR-AT-LARGE *Steve McQueen's frozen corpse*

INTERNS *Some young-ass herbs and bitches*

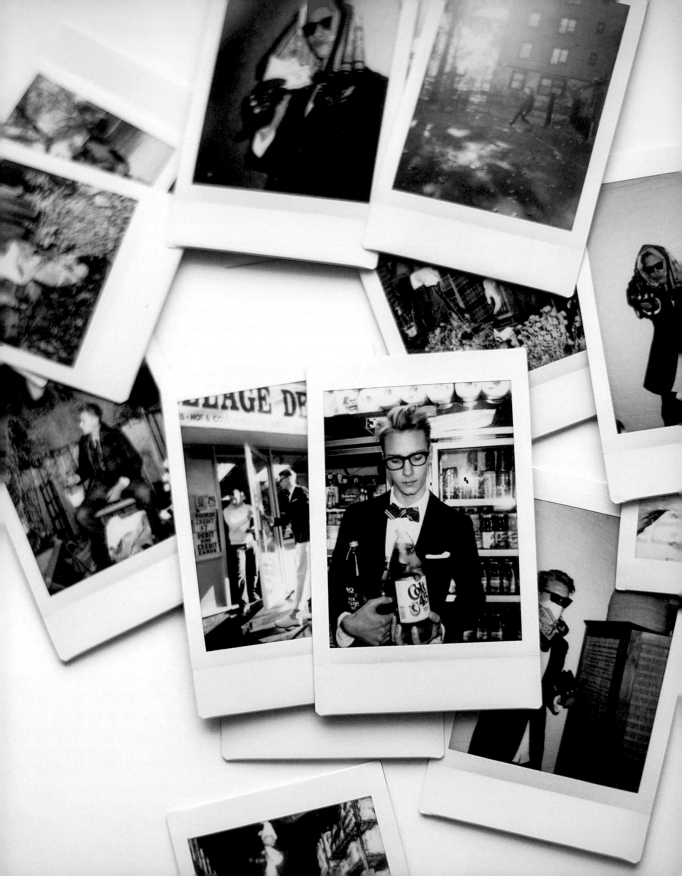

Dear Readers, Thank you for copping *Fuck Yeah Menswear*. As you read through the following pages, prepare yourself for a sartorial-spirit-guided cashmere acid trip through anything and everything menswear-related. A style magum opus—the collected photography, illustrations, and stream-of-consciousness musings before you offer a glimpse into the world of men drooping well. We're talking waxing poetic on waxed jackets, highbrow humor in high waters, and double entendres in double-breasted sport coats. Straight up, son? This book is about looking mad crispy.

For those hoping to find themselves immersed in a "men's lifestyle" guide filled with celebrities, luxury dining, a dash of politics, and the latest travel destinations, go pick up a *GQ* out of a dumpster. Get that other bullshit figured out on your own time. Want to see classy editorials of near-nude starlets? Too bad. This book is about great-looking dudes in great-looking clothes looking like bosses and nothing else. No girls, seriously. We in here to get sprezzed out.

FYMW is about dope product, dope collections, and the steezy world that we call menswear.

What can you expect in the following pages? An Amazonian blowgun full of deadly knowledge darts delivered straight to your cranial. Obviously. As you leaf through, feel yourself getting educated. Menswear is all around you. From musty heritage brands and archive fabric swatches, to identifying the exotic style species found across the cobblestone serengeti that is SoHo, to ruminating on the illest Italians to ever get their photos snapped, we've got you covered. Fair warning. You're about

to begin on a journey that will end in only one way—with you standing naked in an abandoned ravine watching as your old wardrobe slowly burns. We're here to help, but from way deep in the cut, behind the behind-the-scenes. We're not going to hold your hand and walk you to your tailor or cheer as you try on your first pair of raw denim. You didn't get that reference to an obscure collection that dropped five years ago? In Japan? Step your game up. Figuring this ish out for yourself is the whole point. Think of us as your absent father figures. If we're not going to be around, the least you can do is follow in our goddamn footsteps.

If you haven't realized already, it should be painfully clear that this book is grail status. Note the very rare binding and paper stock. We're in the Smithsonian writing history for you philistines. This is an illustrated *Iliad* for the menswear set. Don't sleep. Read it. Refer back to it. Cite it in your dissertation. Owning this book sends a very clear message to your peers, co-workers, and loved ones: "I'm trill as fuck."

Enough talk. Get to reading. When the last four-in-hand is tied and the last blogger put to sleep, it's about the love of the game. It's about respecting the OGs who dressed well before us and the young guns hustling today. It's about dope product, dope collections, and the steezy world that we call menswear.

Fuck yeah,

The Editors

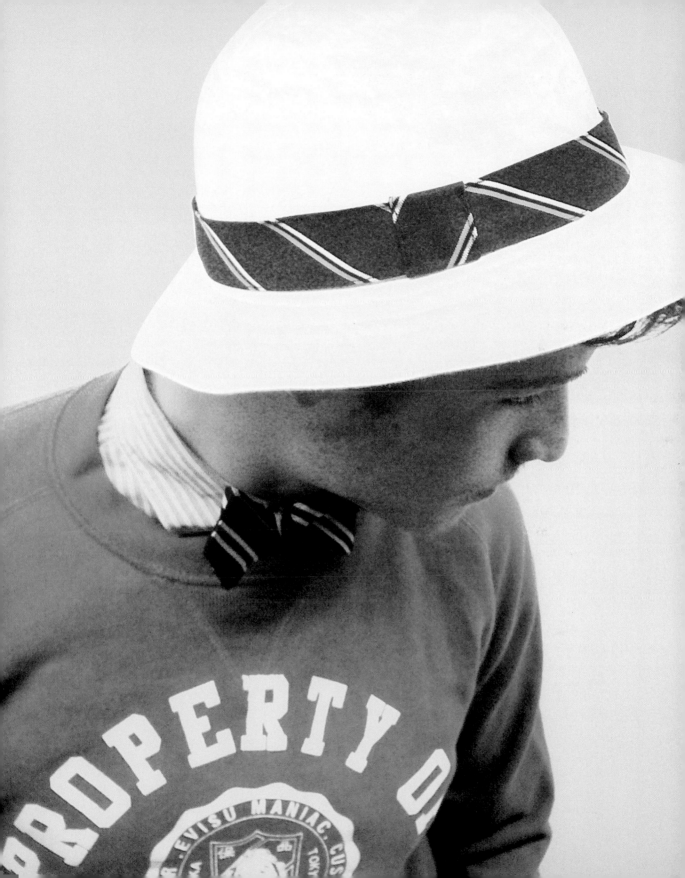

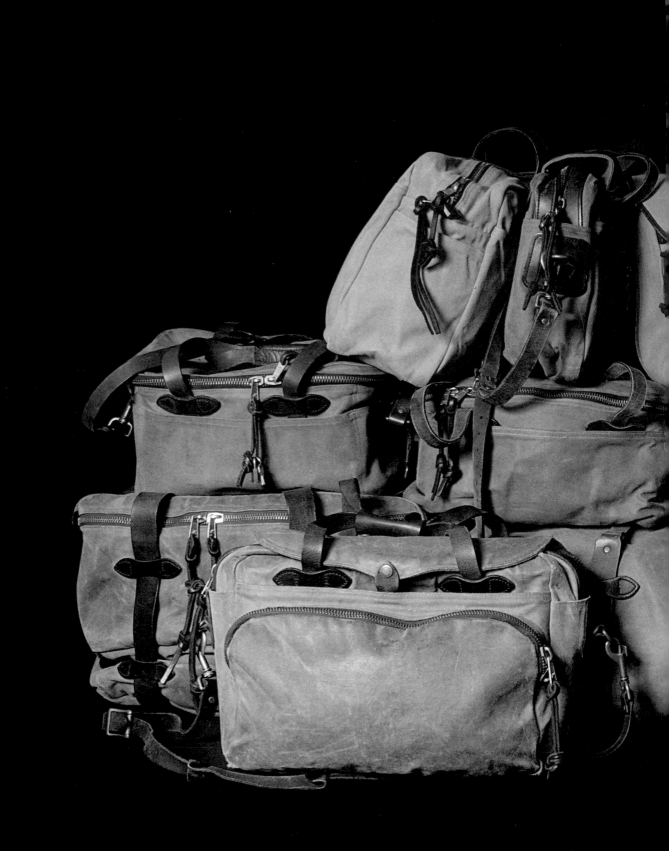

Where the fuck am I?
You can't see me.
That's right.
Fort made of Filsons.
I'm buried under here.
With your girl.
Told her she "might as well have the best"™
She agreed.
While you're out at flea markets trying on
 dead people's clothes,
I'm in my fort playing make-believe.
Make believing I'm not on that next level
 Cookie Crisp.
Make believing I'm not breakin' owls' necks
 when I'm out all night steezing.
Make believing I'm not your favorite blogger.
Never gonna grow up.
Wearing my forest green Macky Cruiser.
No fucking pants on.
Fly as shit.
Call me Patina Peter Pan.
So fucking fly.
In my fort made of Filsons.

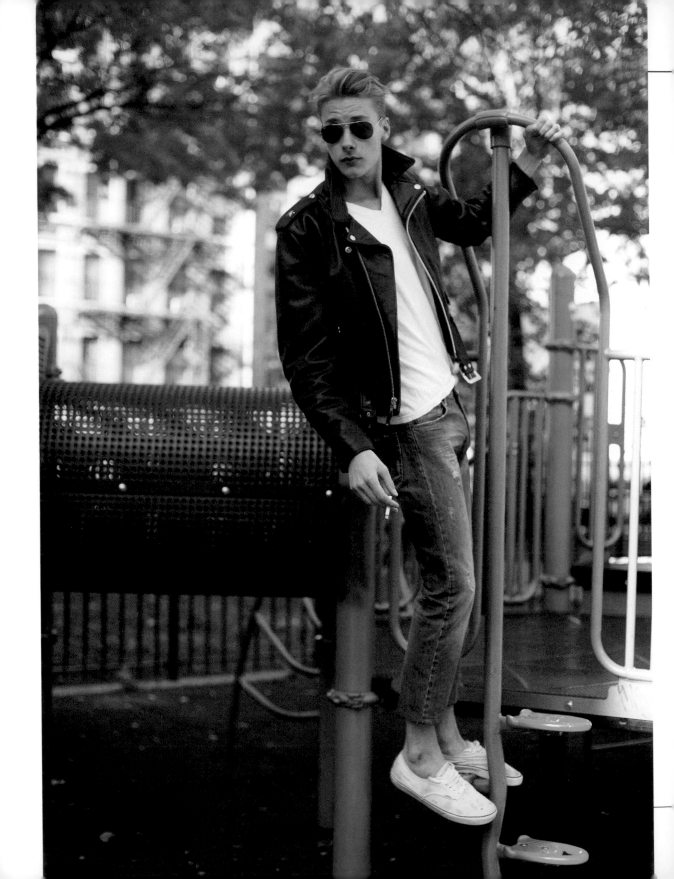

Saturday.
In the park.
My weekend grind.
My side hustle.
Don't tell mom.
The babysitter's dope.
No stache on the grill.
But mad snacks in my stash.
Welcome to the BSC.
Club position: Treasurer.
Club condition: Bottle service.
Stove top cookin'.
Watch the latch.
Go hard on the nipple.
Don't forget to burp 'em.
Ain't no formula for this shit.
Woke up feeling like a wild one.
Fuck it, I'm on one.
Threw on my kit.
Leather jacket.
Great for teething.
Dad Jeans.
Getting into character.
Diaper bag.
MGM.
Mannies gettin' money.
Checked the sched.
Reviewed my notes.
"Naptime is at 4"
"Peanut allergy"
"No more than one pack of fruit snacks"

"Two if he's behaving"
"Richard hates girls (and vegetables)"
Knew we had to take it to the playground.
Rolled up with the koala leash.
Let him loose.
"Do you, son"
Lil' homie went cray on the monkey bars.
Ya'll ready know.
Look at these scrubs.
What is that?
Last season's Crew Cuts?
Who taught you how to layer?
Does your mom dress you or some shit?
Mad respect doe.
To the girl with the purp cape.
Did you see that in Milan?
But don't forget who's boss.
Need to hit 'em with a reminder.
New profile pic on deck.
"Hey, let's play a game"
"It's called 'Stand Here and Push This
 Button When I Tell You'"
"Ever work an iPhone?"
"Don't be a little bitch about it"
Don't any of these cats know how to
 use Instagram?
Posing mad hard on up on that jungle.
The Cig Out.
The Rig Out.
Fig Newton shout-out.
To all the stay-at-homes sitting out
 on the benches.
If the pizza party's where you at let
 me hear you say . . .

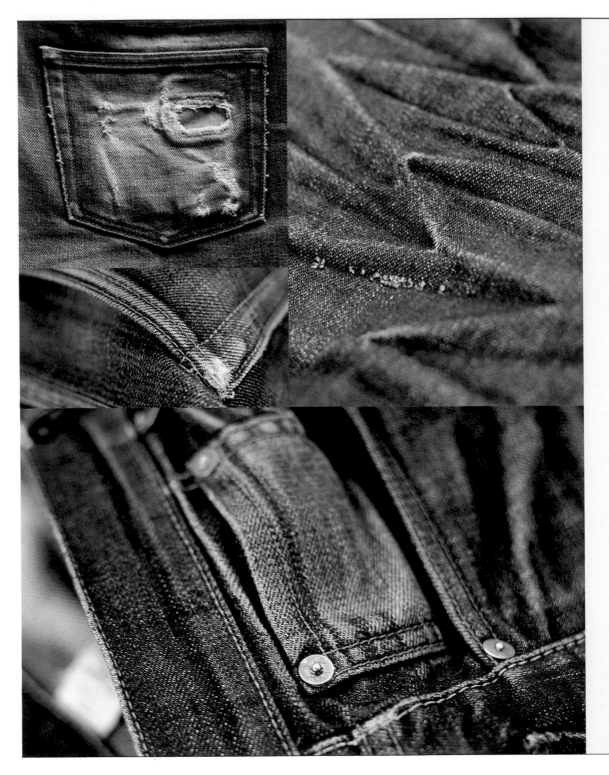

Denim

[**den**-uhm]

Denim is ubiquitous. It is the ambrosia of the legs. It asserts its domain across the bottom half of people's bodies across the globe; sometimes even whole bodies, especially at formal events in Canada. Denim is a cotton twill fabric colored blue with indigo dye. Despite its rich American heritage, the etymology is distinctly European. The blue fabric originated in Nîmes, France, thus "de Nîmes" quickly morphed into "denim." Similarly, the first town in which denim trousers were produced was Genoa, Italy, and from there we derive "jeans." To the uninitiated, a pair of jeans is a completely straightforward garment. You put them on, you wear them everywhere, end of story. But for the menswear acolyte, there are generations' worth of knowledge, endless debates, and intricacies of construction behind every warp and weft. Entire lives have been spent trying to find the perfect pair of jeans, and once one jumps into the indigo abyss and becomes a full-on "denimhead," you'll never be able to have a conversation like a normal person again.

Denim's history begins as a utilitarian fabric of the people. The first pair of modern jeans was constructed in San Francisco by Jacob Davis in 1873 who, partnered with merchant Levi Strauss, sold them to Gold Rush miners. By the 1890s they had developed the Levi's 501, which continues to this

day to be the standard-bearer against which all other jeans are measured. A straight leg construction with five pockets all held together with sturdy copper rivets defines the 501. Workers across the US adopted these new hardwearing pants, but it wasn't until the 1950s when Hollywood put them on the silver screen that they ceased to be clothing and became the iconic symbol of "cool" for America. Countless cowboy films and rebel badasses like Marlon Brando and James Dean showed that jeans didn't play by the rules, jeans were for American heroes, and jeans weren't afraid to take one across the jaw. Gold Rush pioneers mixed with the American love of entrepreneurship and Hollywood cool have made the cultural permanence of jeans as durable as their construction. Jeans quickly became a mass-produced commodity in America, quality waned, and some things that should not have been forgotten were lost.

•

Meanwhile, in the 1960s a Japanese pocket of style started to develop around an endearing love of all things Americana. After seeing screen heroes of American cinema, young Japanese trendsetters began scouring vintage shops for classic American denim. This devotion, not to mention a burgeoning market, led to a number of small Japanese companies buying up vintage shuttle looms and Union Special brand sewing machines from the early 1900s that had been left collecting dust in the States. Inspired by trunks of vintage jeans from American buying trips, these Japanese craftsmen set out to painfully reconstruct the perfect, classic pair of jeans. These beautiful reproductions laid out the foundations for an entire industry of the highest-quality artisanal jeans. While imported denim fabric from USA

heritage sources such as Cone Mills remained popular, over the next few decades the Okayama region (which had been producing cotton weaves since the Edo period) shifted its focus to denim and began producing some of the most valued denim in the world. Japanese brands carried this torch until the turn of the century, when many USA brands picked up and returned to their heritage to begin producing top-quality jeans once again.

The obsession with denim manifests itself most truly, not in the manufacturers, but in the men buying and wearing these engineered constructions. A modern "denimhead" is a man driven by the crippling fear that someone, somewhere, has sicker fades than he does. Once you are at a point in your life where you've spent over two hundred dollars on a pair of jeans, you can either develop a cultlike obsession with them or get hit with a terminal case of buyer's remorse. Unsurprisingly, most prefer the former. The upkeep and the evolution of the jeans as you wear them must take the highest importance in the life of a denimhead. Jeans are worn every day for at least six months (two years if you're trill as fuck) without ever letting them touch soap or water. Understanding that your indigo-soaked companions have taken up a personal vendetta against any and all white couches is eminently important. Carefully selecting which pockets your phone and wallet go in so that you get those perfect, tasteful fades can take weeks of preparation. You deal with the emotional roller coaster of the pain and subsequent joy that only a rip and repair can provide. And when it does finally come time to wash, the denimhead will carefully soak their jeans in bathtubs or wear them out into the frigid ocean, letting the saltwater work its magic in accenting the now-deep fading. A love develops unlike any other. All for a piece of clothing. These are your jeans. This is your life's work. ■

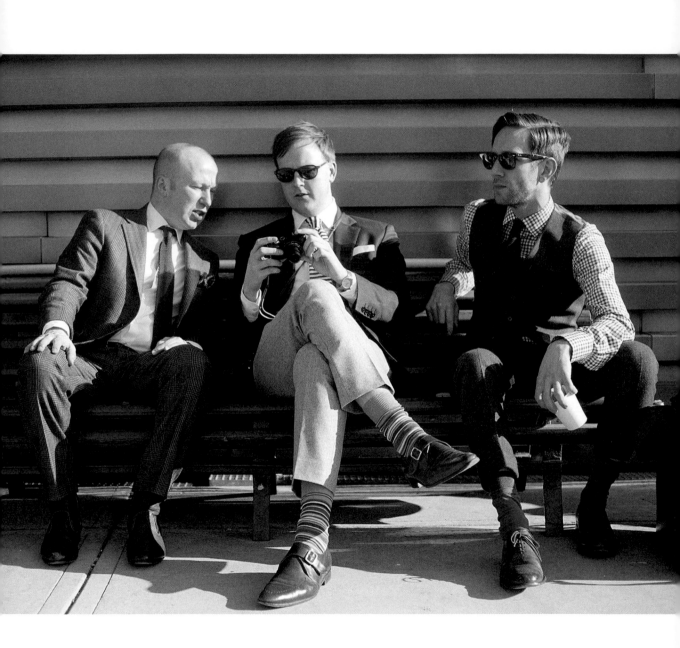

Shut up.
Just, shut up.
Look how fat he looks in this photo.
Can you believe he showed in Paris this year?
Wearing that?
Ugh.
I didn't know whales was trending for A/W.
We're so bad.
It's not our fault though.
We're just more popular than everyone else.
We're just more well dressed than
 everyone else.
We're just more handsome than
 everyone else.
Did you hear Colette dropped his account?
Whose?
Rachel's old boyfriend.
The wanna-be Junya guy?
Yeah.
Guys, guys.
Shut up.
Be cool.
Photog walking by.
And pose.
And pose.
Don't make eye contact.
And pose.
Ok, good.
I think he got me.
I mean, I think he got us.

What kind of trendphobic dickhead still
 wears camo?
Digi-cam can't hide that acne.
Did you hear?
His parents are getting divorced.
Retail therapy ain't gonna help this time.
Oh my god.
Did you see that new Harris Tweed?
The orange or the brown?
Orange.
So dope.
So dope?
So.
Dope.
Oh my god.
Guys.
We're just so fucking popular.

Fuck an Olsen twin.
Ya heard?
I've been on that homeless tip.
Before fleece was black at The Brethren.
Before Press was in Urban.
Before BK cats were shaking down each
 other for cookie boots.
Before this shit was a movement.
Smell me?
So don't be asking where my cup is at.
Tryna give dude pocket change.
So I can get some malt liquor and a
 bag of Funyuns uptown.
Do you see a sign?
"Will design for food."
Blogger, please.
Scotty wasn't the first dude to bug out
 on hobowear.
And he definitely won't be the last.
You think I wake up in the morning.
Throw a new patch on my chinos.
And think to myself.

"Damn, it feels good to be an icon."
Fuck outta here.
There is natural swag.
And then there is NATURAL SWAG.
I've been a walking moodboard, kid.
Inspiring generations of steezheads.
Every time I take a stroll down Bleecker.
A G-wich Village nomad.
Making appearances at The Mansion.
When some fresh-faced asshole from Parsons
 needs a second opinion on a drug rug
 poncho he's cooking up for 'Lo.
Just because I run shit.
Doesn't mean I have to like it.
So when you see me, keep it moving.
No hat tips.
No pics.
No questions.
Unless of course, you want to know what
 it's like to sell Lifshitz a dream.
And smoke weed in a teepee on the
 double RL ranch.

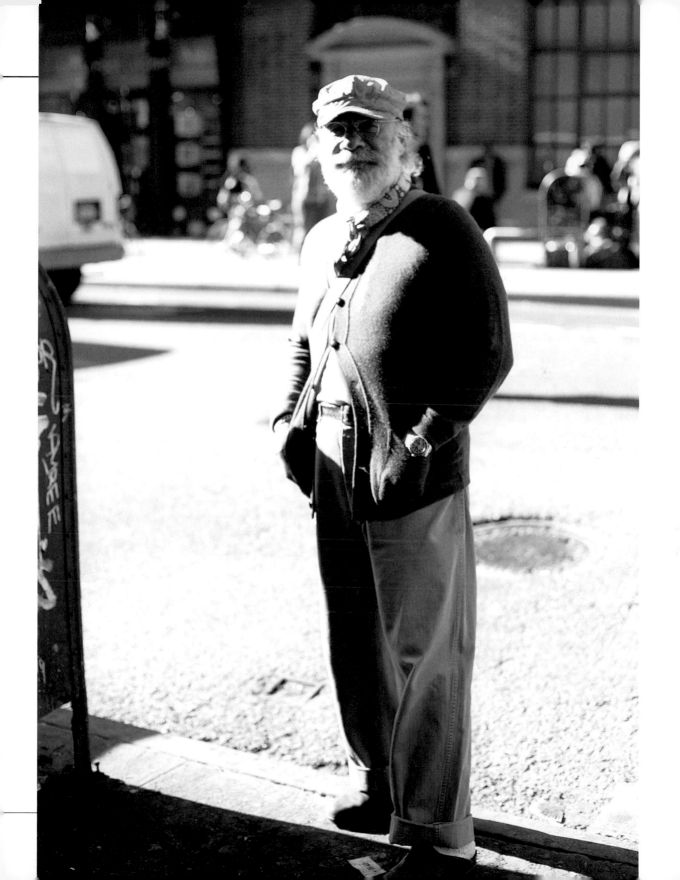

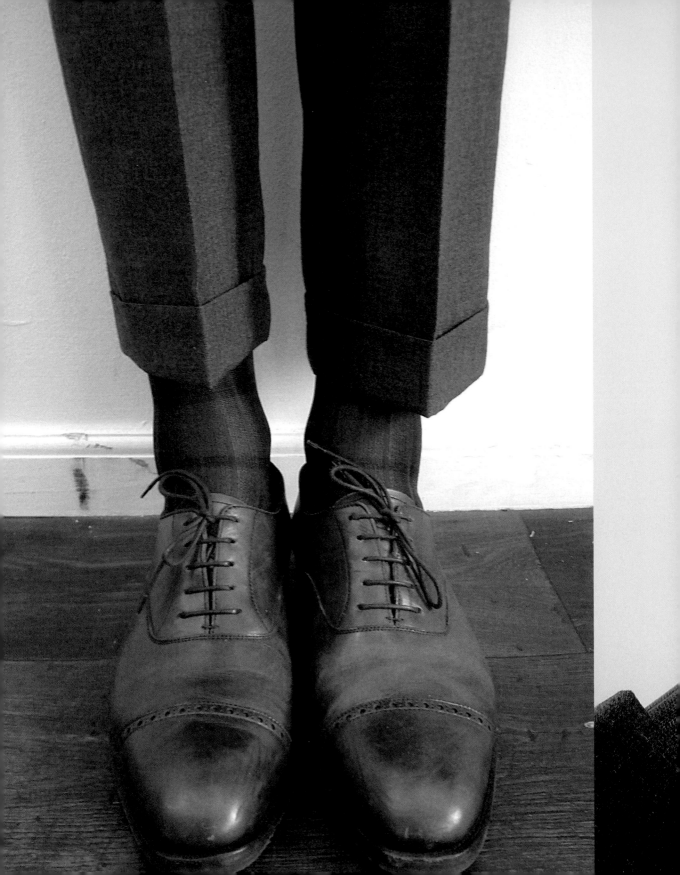

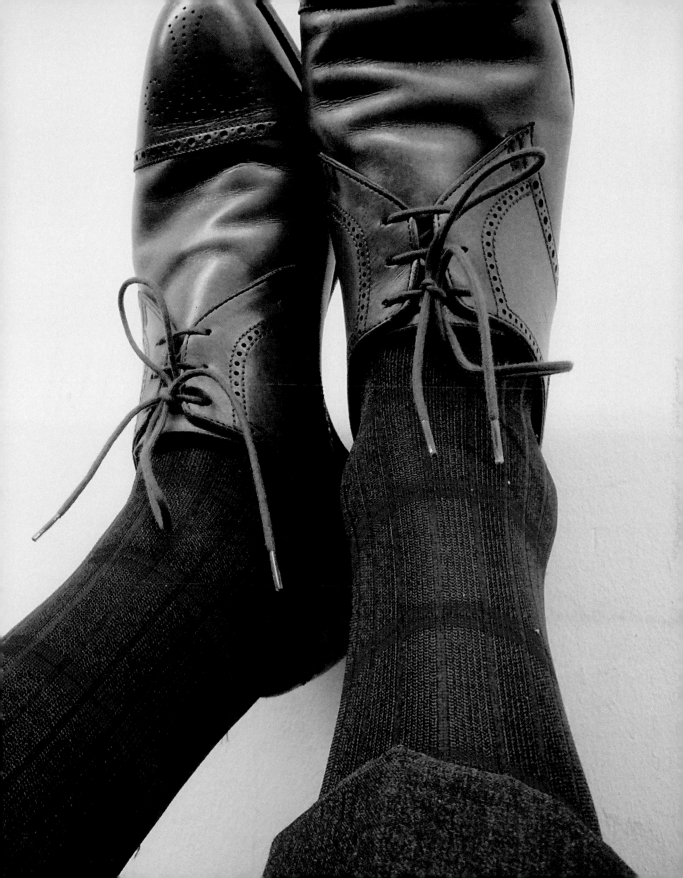

Howl at the moon.
Before time.
There was another time.
When clothes were just clothes.
And it was good.
Rested on their hangers.
All the world slumbered quietly.
The wind rustling through samples.
Dotting the trees in the nighttime.
And Man was not yet made.
From clay on the banks of the lonely
 billabong.
One handful at time.
Laid like bricks.
One after the other.
Packed in the sun.
To harden.
To dry.
Once set, the man stood up.
And asked, "Why is Man made different
 from clothes?"
"Where are my seams?"
"Where are my buttonholes?"
"Shut the fuck up you noob," said the
 Craftsman.
For he was an impatient god.
Who in an act of rage cast down his tools.
And showered the world in sparks.
Quicksilver rained down.
Mercury poisoned the land.
And Man was afraid.

Soon the fiery sky grew dark.
And even though he was freshly made.
Man knew that there was a formal event
 at 8 pm.
And Woman was not yet created.
So it would definitely be a sausage fest.
But Man was vain.
Like his creator.
Alone in the blackness.
Man shuddered with the birth of cold.
And he wanted to show up looking like a don.
He crawled into the small of a thicket.
His back scratched by the thorns.
Man was alone.
In his naïveté, confusion became him.
But the Craftsman had not brought Man
 into an empty world.
No, on the backs of Man would nations
 be forged with style.
It was then Man felt something soft.
Sweet embrace.
The hush of cotton.
The shimmer of pearl in the dark.
Shirt was there.
Shirt was warm.
Man put on Shirt.
And looked fuckin' crispy.

Meeting called to order!
Silence!
Meeting called to order.
Cool Dudes Club.
Is now in session.
As always.
First, the club rules:
No girls.
No parents.
No bedtime.
Cool dudes for life!
On to the agenda for today.
Do cool dudes ever grow up?
No.
Cool dudes are young at heart.
Cool dudes are forever young.
Sometimes we have ice cream for breakfast!
Next item.
Can a cool dude date a model?
No.
Club rule number one.
No girls.
Duh.
Cool dudes follow the rules!
What's next on the list?
Do cool dudes pop collars?
Dude.
Yes.
Duh.
Cool dudes always pop collars.
It's the signature move of the cool dude style.
How do cool dudes party?
With brews.
And with other cool dudes.
Duh.

Moving on.
Did anyone see a hawk today?
I saw a hawk today.
HAWK DAY!
HAWK DAY!
HAWK DAY!
And you know the rule.
If you see a hawk.
You gotta buy all the cool dudes lunch.
So, how does a dude become a cool dude?
I mean, dudes are dudes.
But some dudes are cool.
Club rules in favor of cool dudes finding
 new cool dudes.
But only if the new cool dudes.
Are double cool dudes.
Wrapping up.
THE OATH!
THE OATH!
THE OATH!
COOL DUDES LOVE COOL DUDES!
COOL DUDES HANG WITH COOL DUDES!
COOL DUDES FOR LIFE!
Ok, guys.
I have to go meet a buyer about S/S 13.
Sounds good.
Yeah.
I think I need to call my wife.

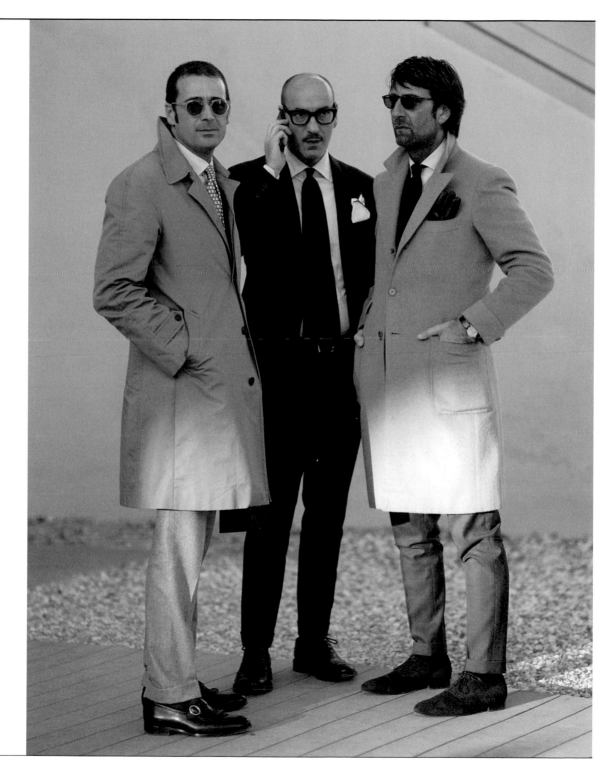

"Hey. Do you remember when we used to hang out with ugly people?"

"No . . . cause that never happened."

STYLE ARCHETYPES

As hard as we all try to get steezed out, the reality of the situation is that we're still just playing a part. A part that falls in line with generations and generations of menswear fiends. A part that can be easily stereotyped and made fun of. The following pages present a look at the definitive style archetypes and what sets each apart.

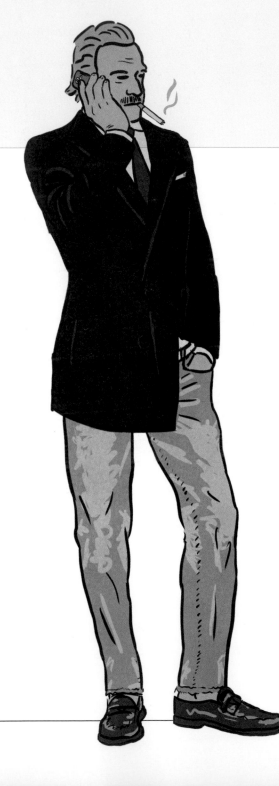

- AGE: 40 and up

- STRENGTHS: Double monks, double-breasted suits, double four-in-hand knots, double anything to be quite honest, dad jeans

- WEAKNESSES: Carbs, mistresses, Ferraris, lung cancer, technology, English

- FAVORITE BRANDS/DESIGNERS: Whatever he and/or his family has a controlling stake in. Examples include, but are not limited to Isaia, Borrelli, Boglioli, Lardini, and any other brand that sounds like it easily could be a pasta dish you had that one time on "vacation."

Sprezz

The smoking street-style unicorn,
the Pitti Uomo peacock with panache, *this* is
the sprezzed-out Italian gent. With facial hair
worn without a single hint of irony, his sense
of taste is off the charts and helps influence
countless broke underclassman across the
Atlantic. His greatest attribute, bequeathed
at birth, is his innate understanding and
execution of *sprezzatura*. Odds are his family
has done this kind of thing long before the
internet was invented, and he probably has no
idea that the internet even exists. Aspiration
need not apply in this case. Out of all the
style heroes, he truly lives it.

Heritage

Nostalgia drunk deep from the waters that carved the Appalachians. This guy only concerns himself with clothing that was made for hardworking men in even harder times. Clothing that is built from the ground up. Prepared on the daily to cut cords of wood or build railroads, this guy feels at home in denim, waxed jackets, and thick, sturdy boots. A history of excellence is what this guy strives for. Ernest Hemingway, Steve McQueen, and other dead guys are the icons this dude shunned his father for. Each time he pulls on his heavy wool overcoat he becomes part of a long tradition of making this nation great, whether walking to the local bodega or debating if his favorite brunch place will be totally swamped.

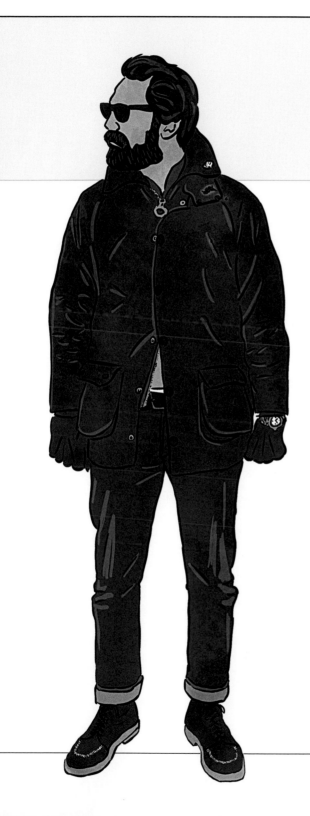

- AGE: 25–45

- STRENGTHS: Obscure beers, repelling water, beards, brand history, judging authenticity

- WEAKNESSES: Manual labor, overpriced notebooks, patina, compasses, outsourcing

- FAVORITE BRANDS/DESIGNERS: Barbour, Filson, Alden, Red Wings, Levi's, L.L.Bean, Woolrich Woolen Mills, Engineered Garments, Pendleton

- AGE: 20–30

- STRENGTHS: Gundam, fancy ramen, pronouncing Japanese brand names, memes, StarCraft

- WEAKNESSES: Talking to girls, going out in public, organized sports, bright colors

- FAVORITE BRANDS/DESIGNERS: Comme des Garçons, Undercover, Yohji Yamamoto, Kris Van Assche, 3.1 Phillip Lim, Rick Owens

Goth Ninja

Not limited to anyone even remotely talented in marital arts, this all-inclusive archetype is prevalent in a youth culture obsessed with avant-garde high fashion from Europe and technically advanced fashion from Japan. With a simple color palette of blacks, greys, and whites, the goth ninja looks like, well, a goth ninja. Though the final results may perplex, confuse, and scare young children, we must acknowledge the deep pockets and discipline of any goth ninja disciple as this rare look is difficult to achieve. Preferring the comforts of one another to outsiders who think they look like *Star Wars* characters, the goth ninja is a pack animal.

Euro Jetsetter

Maybe the slickest and smoothest of the bunch, the European fashion guy toes the line between dressing too young for his age and being the best dressed guy in the room. He's a man of few to no words, but his longing gaze could transcribe a novella. Never one to flaunt his taste, he keeps logos and embellishments to a minimum. He pays a premium to look nondescript. He's not so much expertly tailored as he is simply wearing skinny everything. The European fashion guy might be looked at sideways when he's in the boardroom, but he's leaving the party you weren't invited to with your wife.

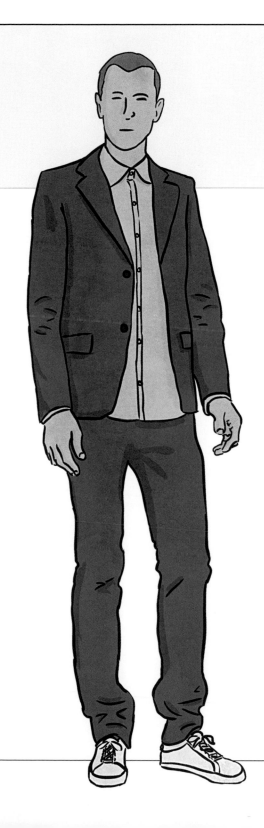

- AGE: 25–45

- STRENGTHS: Scooters, small talk, height, sparse facial hair, rich friends, foreign languages, socialism

- WEAKNESSES: Pleats, black-and-white photography, punctuality, dancing, public transportation

- FAVORITE BRANDS/DESIGNERS: Dior, Lanvin, Yves Saint Laurent, Our Legacy, Maison Martin Margiela, Raf Simons

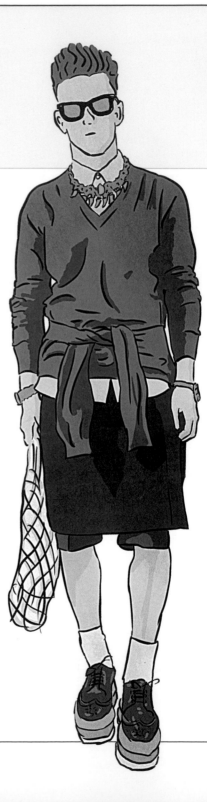

- AGE: 18–30

- STRENGTHS: Sample sales, blogging, cheek kisses, brand whoring, having something in common with women

- WEAKNESSES: Reality, free champagne, walking comfortably, dress codes, stairs

- FAVORITE BRANDS/DESIGNERS: Gucci, Prada, DSquared², Dolce & Gabbana, Marc Jacobs, Versace, That one brand that reached out to them via email

Fashion Victim

The identity of the fashion victim is that of no identity. Defined by brands, labels, price tags, and trends, the fashion victim is a chameleon that changes season after season. They never wear the same thing twice and never look like a person with even an ounce of good taste—the personification of gauche, if you will. The fashion victim's life revolves around clothing and the industry they love. They dream of the front row, and even the tiniest bit of designer gossip gets their full attention. Ultimately, the fashion victim must do their best to monitor their appearance at all times lest they end up an old, asexual, incoherent mess. At a certain point you are, indeed, too old for this shit.

Prep

"Go to hell," is what you want to say to a prep, but their clothes and money have already beaten you to the punch. Game, set, critters. What the prep lacks in self-awareness, he makes up for in bravado. His loud dressing seems douchey to those around him, but it's this very douchiness that seems to fuel his daily sartorial routine. Often the most imitated archetype by status-seeking outsiders, a true prep would tell you he was born, not made. When not hitting on liberal arts college sorority sisters in mud-caked Bean boots at keggers, a prep is usually trying to figure out if their pink button-down shirt is theirs, their dad's, their sister's, or if they just suck at doing laundry because the help is sick that day.

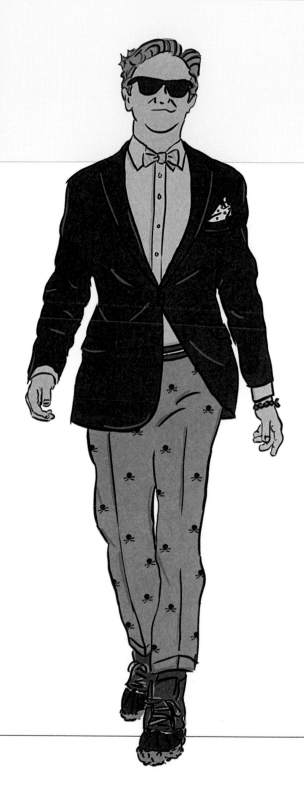

- AGE: 14–26

- STRENGTHS: Owning bulldogs, being Caucasian, using nouns as verbs, spending money, croakies, being a dickhead, brunch

- WEAKNESSES: Bloody Marys, girls with pearls, family alcoholism, pleasing one's parents, law school

- FAVORITE BRANDS/DESIGNERS: Ralph Lauren, L.L.Bean, Vineyard Vines, J.Crew, Sperry

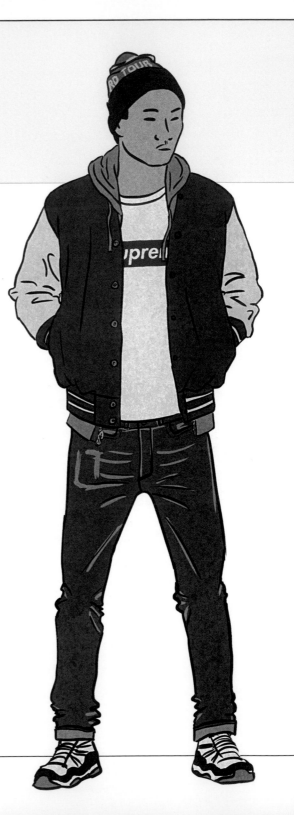

- AGE: 13–26

- STRENGTHS: Copping, waiting in line, keeping sneakers packed away in shoeboxes, fitting into jeans two sizes too small, memorizing rap lyrics, making threats over the internet

- WEAKNESSES: Dead stock, collaborations, full-time employment, the opinions of others

- FAVORITE BRANDS/DESIGNERS: Supreme, A.P.C. (but only denim), Vans, Vintage Stussy, Jordan Brand, Jeremy Scott

Hypebeaster

Only second to the Fashion Victim in their brand whore tendencies, the Hypebeaster feeds off urban culture and whatever has the streets buzzin'. Hypebeast culture is that of one-upsmanship and gamesmanship with fellow 'beasters. What at one point was merely a battle of footwear has now spilled over into the world of apparel. The latest and greatest caps, varsity jackets, and even denim are now targets to maximize freshness and, subsequently, bragging rights. Hypebeasting does not come cheap, as exclusivity is king. It is not uncommon to find a young hypebeaster living paycheck to paycheck from his retail job, having spent all his money on the latest Air Jordan re-release.

Ivy/Trad

Classic American collegiate style.
Originating in the 1950s from men's shops
such as J. Press and the Andover Shop, who
outfitted the youth of Ivy campuses like
Harvard and Yale. The 1960s saw Jazz greats
such as Miles Davis adopt the look and inject
it with the ultimate dash of cool. Oft heralded
as the peak of American sportswear, it's no
wonder people from the future still dress like
this. Keys to the look are three-button sack
suits, natural shouldered jackets, slim khakis,
knit ties, and button-down shirts. If you put
on your kit and look like a boring old man,
you're absolutely crushing it.

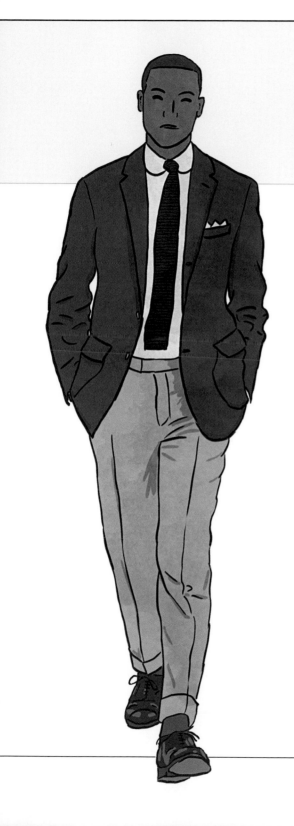

- AGE: 35+ (1960s 18–21)

- STRENGTHS: Nostalgia, SATs, driving Beemers, looking like a college professor, smelling musty

- WEAKNESSES: Subtle monograms, secret clubs, Jazz lounges, talking to philistines

- FAVORITE BRANDS/DESIGNERS: Brooks Brothers, J. Press, Andover Shop, Alden, vintage

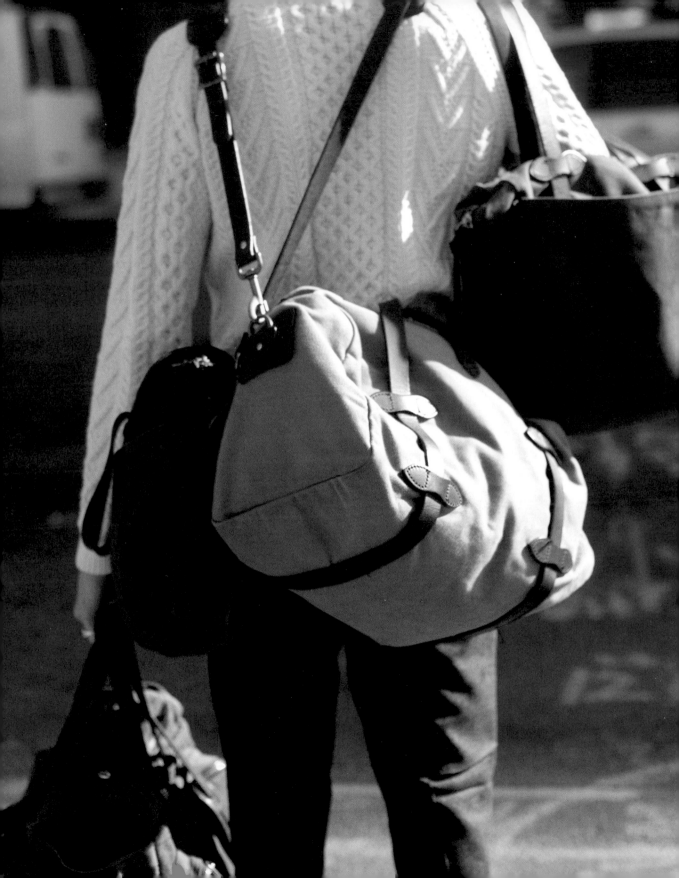

Flights booked.
Worldwide.
Filson tasting tour.
Leggo.
Sampling the finest rugged twills.
Waxed cotton aged to perfection.
Barrel-soaked leathers.
In the finest locales.
Jetsetter.
Trend selector.
Bag collector.
Itinerary flex.
Timeline travels.
Boarding pass boast.
JFK --> SEA.
Leg one.
Checkpoint holdup.
Security pat down.
Happens on the reg.
Mismatched Happy Feet.
The only shit that's random about this search.
Riding dirty in the golf cart.
Got a rezzy at The Admirals Club.
Gate 25.
Walk the red carpet.
Plebes checking me out behind the velvet rope.
Peep the legroom.
Stewardess spilled the third complimentary mimosa on the OG brief.
Time to close the curtain on economy.
And pass the fuck out.
Baby Milo on the eyemask.

Touched down in The Emerald City.
The birthplace.
We start with a rare '87.
Deadstock.
Unzip and let it aerate just a minute.
Now stick your nose in.
Deeper.
Don't be shy.
And take it all in.
Hints of exploration.
Just the faintest ruggedness.
Possibly a splash of gunpowder?
Superb.
These so-called aesthetes are neophytes.
They work in broad strokes.
"Classic"
"Manly"
"Americana"
But I know that it's the flutter of
 ripe pioneers.
Impregnated with even the slightest promise
 of The Great Klondike Gold Rush.
That's got my dick hard.
Copped a case.
SEA --> HND
Leg two.
Head upwind to Beams.

Investigate some exotic vintage.
They pull out a '09 limited run.
Pah-lease.
Everyone knows the unfavorable winter that
 year ruined the whole batch.
Frozen hands were too cold to sew.
Imperfect stitches.
Totally botched.
Packable, but far from transcendent.
Didn't even bother.
People just don't understand.
I like to think about the life of a bag.
I like to think about what was going on
 the year the bag was made.
How the sun was shining.
If it rained.
I like to think about all the people that
 stitched and sewed the bag.
And if it's an old bag.
How many of them must be dead by now.
I like how bags continue to evolve.
If I opened a bag today it would pack different
 than if I opened it any other day.
Because a bag is actually alive.
It's constantly evolving and gaining complexity.
That is, until it peaks.
Like the '09.
And then it begins its steady, inevitable decline.
But it looks so fucking good.

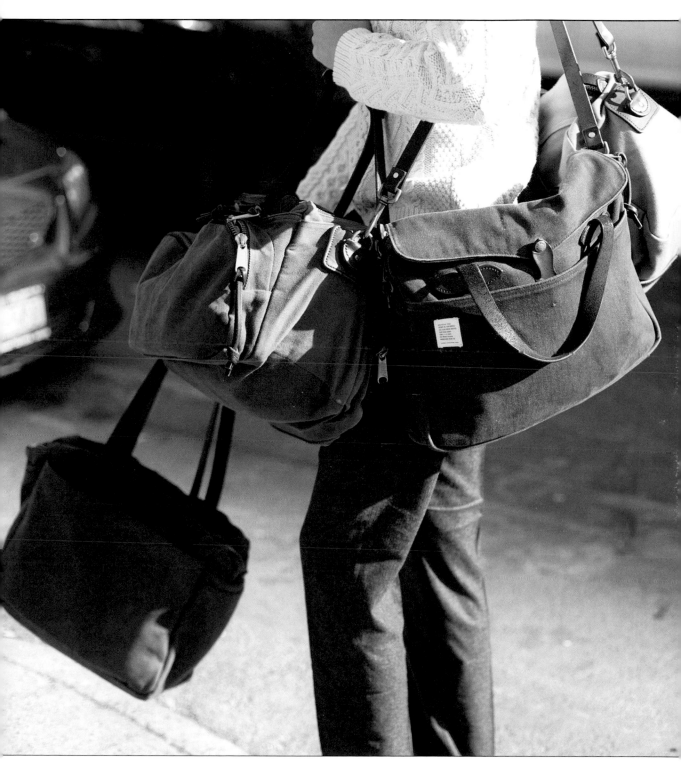

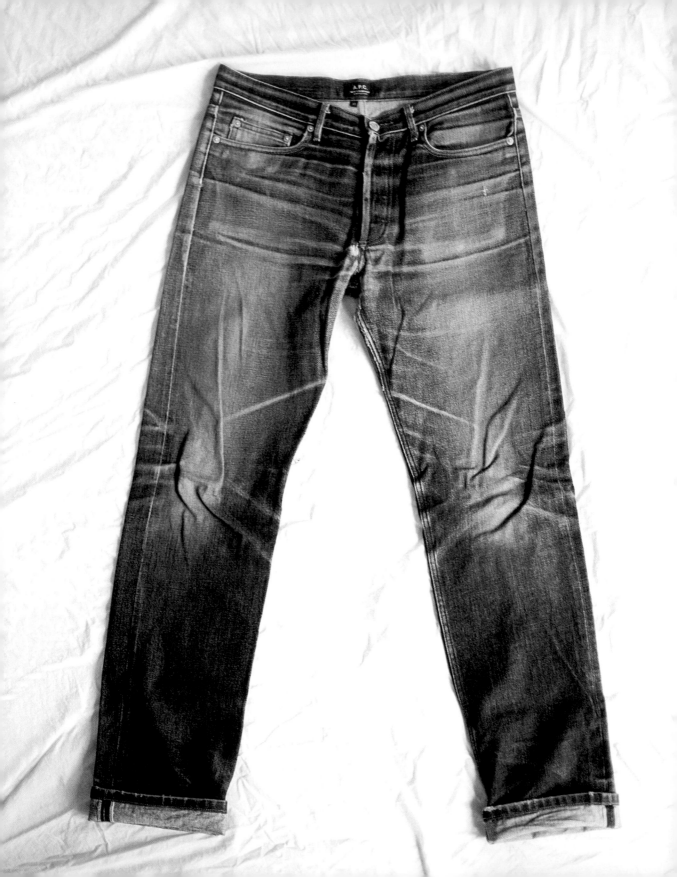

Requiem for a denimhead.
This is not a cry for help.
I'm in control.
I know my limits.
Sitting in health class.
16 years old.
Beasting with 3,000 posts to my name.
bigwilliesteelo92
Teachers tried to warn me.
Fuck you.
I don't have a problem.
You MADD, son?
Mothers Against Denim Debating.
Bought my first 14 oz. off some shady Sufu kid.
Gave it to me dirt cheap.
A.P.C.
The gateway denim.
It was fun at first.
Just fucking around with my friends.
Seeing how crazy we could get our wallet fades
 without our rents finding out.
One night my mom found my stash when she
 was cleaning.
Some dope proxy ish.
She flipped the fuck out and washed them
 before I could stop her.
Six months and $200 gone just like that.
My friends lost interest.
To them it was just about cool stacks and fades
 to go with their tees and box logo snapbacks.
But I was hooked.
It took more and more to get that same feeling.

Started getting into some heavier shit.
16 oz.
21 oz.
32 oz.
Getting so fucked up.
Getting so faded.
Jeans so stiff.
They were the only things keeping me
 on my feet.
Eyes bloodshot with selvedge lines.
Shit got bad.
The night terrors.
Waking up in a cold sweat.
Sheets dyed with indigo.
One night my bros found me.
Curled up in the gutter.
Rubbing sandpaper all over myself.
Screaming.
Into the darkness.
MOMOTARO!
They saw the honeycombs on my legs.
Tried to talk to me about addiction.
But I don't have a problem.
Fuck an intervention.
Stop calling my brothers and sisters.
I call my dick my pussy.
My crotch got so many whiskers.

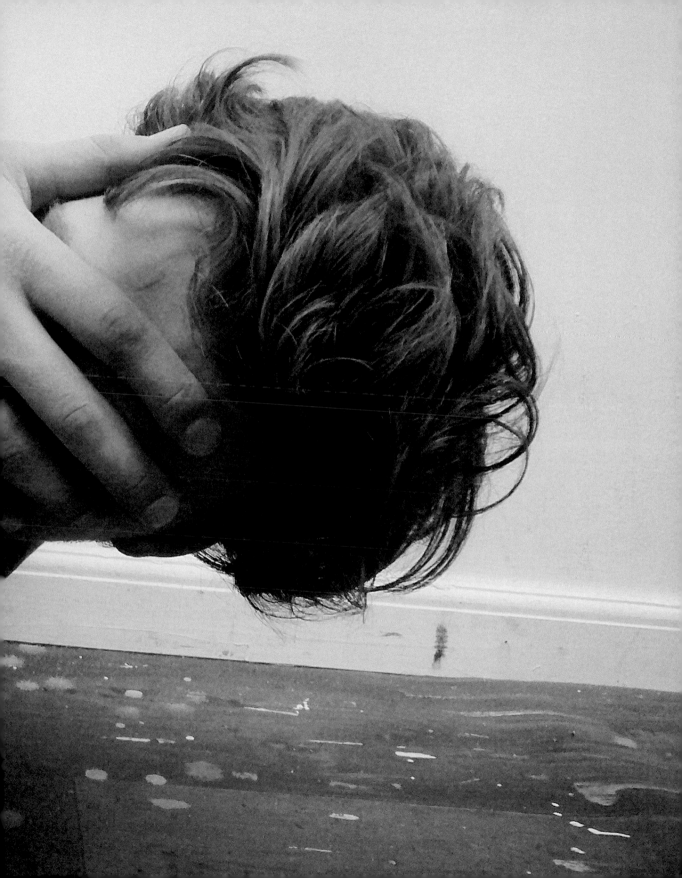

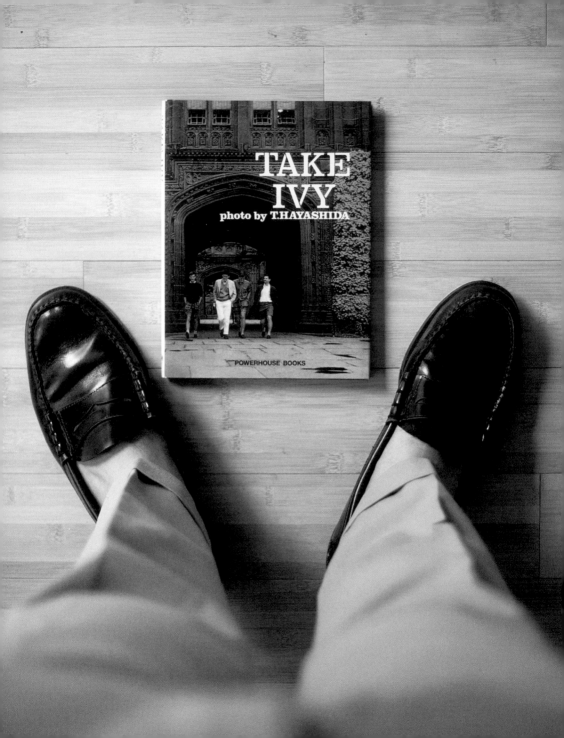

I took the fucking Ivy.
Standing on my hardwood floor.
Pennys with no socks.
Natch.
POV shot.
This shit is straight porno.
I'm a fucking cinematographer.
Who the fuck are you?
I'm Trad in a toaster.
Fucking crispy.
Glad Powerhouse re-published.
I only buy Made in the fucking USA.
Got this shit fucking pre-order.
Haven't even opened the book.
I fucking been had the scans.
In photo class at my liberal arts college.
Name dropped T. Hayashidy.
Prof had no fucking clue.
So not Ivy.
Ivy is not one of eight prestigious unversities.
Ivy is not Madison Avenue.
Ivy is not Brooks Brothers.
Ivy is not modern Jazz.
Ivy is my BA in clownin' on bitches.
Ivy is my crotch out of focus.
Ivy is standing in my iced-out apartment.
Steezing for my followers.
I took the fucking Ivy.

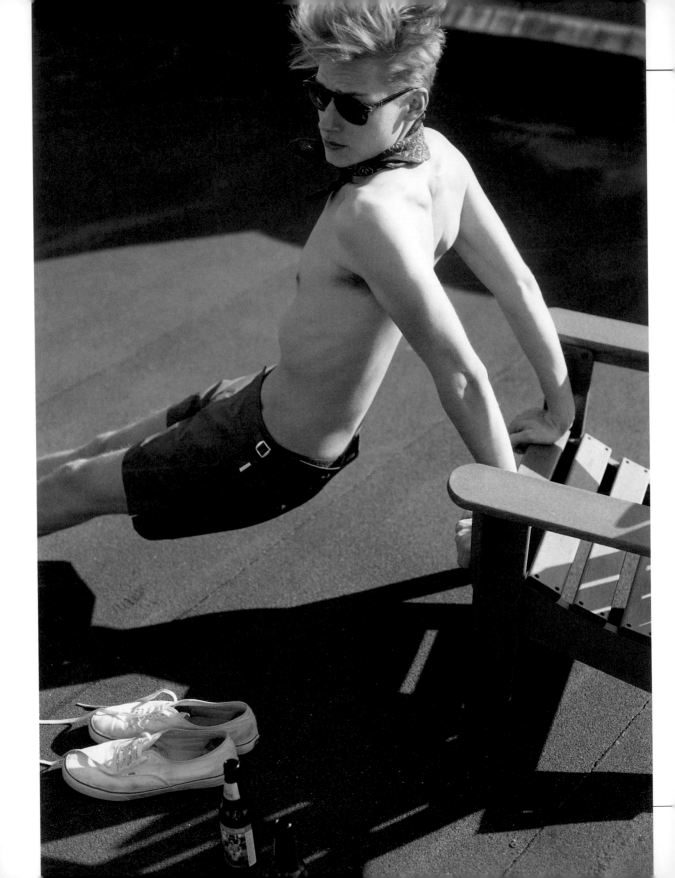

Fitness is the ultimate luxury.
Packing a closet full of Caruso.
And seam ripping patches off Rugby cargos.
Don't mean shit.
Unless you're ripped yourself.
Roof deck.
Sun deck.
Twenty reps.
Twenty reps.
Twenty repetitions.
Timeless bitches.
Hepburn.
Bardot.
Oprah.
Call for a timeless physique.
Hand clap pushups.
Between hashtags.
Full lunges.
Between samples sales.
Mind foggy from exhaustion.

Or maybe those beers at brunch.
To the face.
Downward-Facing Dogfish.
Half Blue Moon Pose.
One-Legged King Cobra.
I pre-game life.
Competing at my level takes dedication.
Building stamina.
Searching for that second wind.
Racing down the street.
Between Bergy's and The Barn.
Where do true heroes live?
In the hearts of men?
In the fingers of man?
The dashes of thousands?
Lats.
Quads.
Glutes.
Pull ups in the club.
Sippin' champagne flutes.
Tonight we're winnin' one for The Wooster.

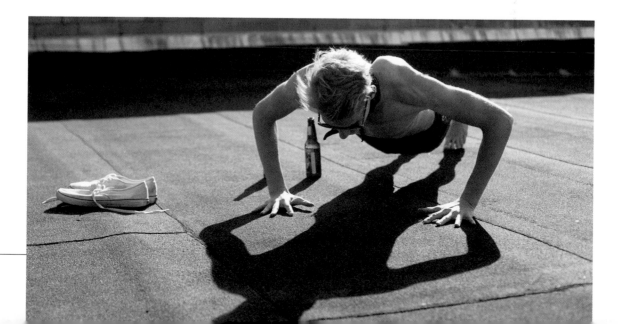

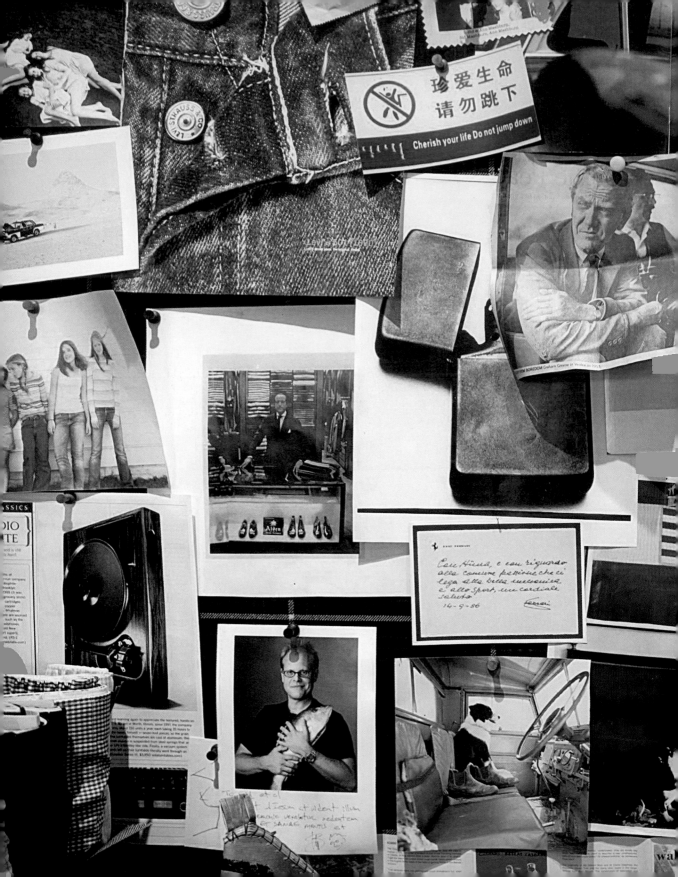

珍爱生命
请勿跳下
Cherish your life Do not jump down

MOOD BY NUMBERS

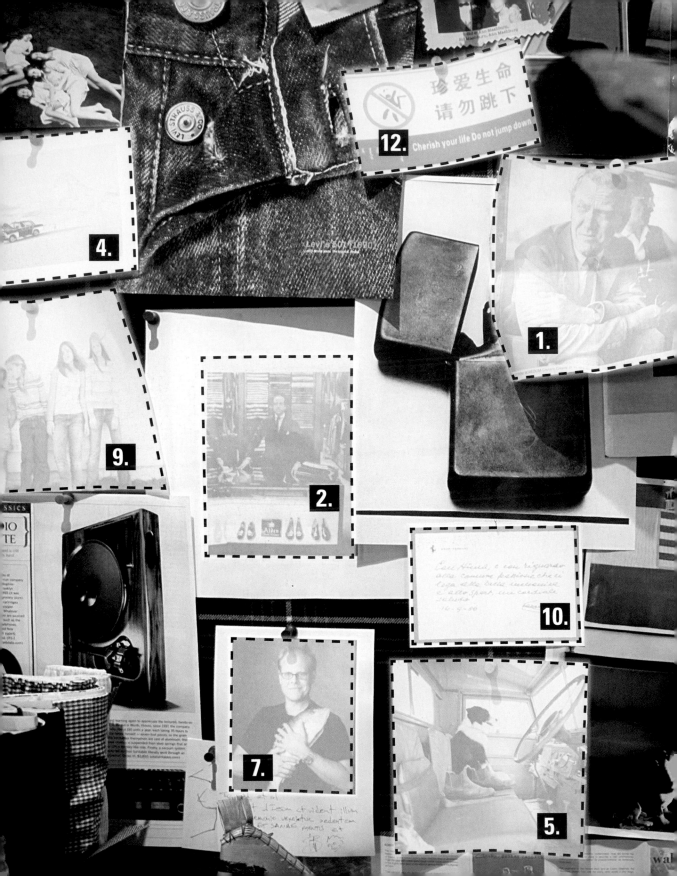

Made in the USA

Make a fist like the one on your afro pick and come ten-fold strong with the bomb.

11.

6.

3.

8.

was her first and last story with Slim Aarons, a one role that was utterly unbreakable. Slim of-ching with Princess Grace of Monaco and her ess Caroline in Salzburg in the 1970s (where else eizer Hirsch?), both of them begging him to hire ways laughed heartily at the port at which he said om and asked pointedly, "But, Caroline, can you sornings?" They in turn looked at him, dumb-dly, back then she was not an early riser.

ght, off Capri in 1968. Opposite: Two of his most ic images. The 1959 classic at top captured "one ls"—C.Z. Guest along with her son, Alexander, ind Parky)—and "one of the greatest pools"—at r Artemis, a Guest family home. Below, Clark Gary Cooper others

I was singularly unqualified to write articles and captions for Slim's photographs in T&C, but having worked on a cattle ranch in Oklahoma for the previous few years, I certainly had no trouble getting up in the mornings. It helped that I was well-traveled, spoke three languages, hated dry-cleaning chemicals and came highly recommended by a family friend, J. Patrick Lannan, the longtime head of ITT, who knew Frank Zachary quite well. I was also an earnest student of the history of photography and loved to pick up a camera myself from time to time.

but, most important, and I realised this years later, I think that at that moment there was no one else willing to take the job who could juggle its particular requirements, supreme among them being a talent and patience for dealing with difficult people—and here I'm not referring to our photo subjects. Anyone who knew Slim fairly well understands that to say he was demanding is a

MOOD BY NUMBERS
(for ages 10+)

1. Safari campsite. Bonus points for every pith helmet.
2. Black-and-white glamour shot of Grace Kelly.
3. Pulled over red Ferrari Testarossa on fire.
4. Vintage advertisement featuring The Arrow Collar Man.
5. Random Penguin Classics book cover.
6. Handsome actor, preferably dead, smoking on a motorcycle.
7. A swatch of fabric. Including, but not limited to, black watch.
8. Behind-the-scenes shot of Stanley Kubrick directing.
9. Mili-spec garment diagram.
10. 1980s shirtless skateboarder shredding a pool.
11. Talking Heads album liner notes.
12. Foreign film still. Subtitle must be existential in nature.

You young motherfuckers take this shit for granted.
Have you ever poured out some cashmere socks?
In honor of how far we've come?
These barriers of entry were torn down
 many years ago.
Thanks to people like me.
People like me who stuck their neck out.
People like me who were willing to catch
 an indictment.
Know this.
Nobody wants to catch an indictment.
Even if they got the money for the lawyer doe.
See, we weren't always untouchable.
Sometimes the man tries to break your spirit.
And sometimes he succeeds.
Back in the day this shit was more than a sport.
And our own greed brought our downfall.
A Boglioli DB every day of the week sometimes
 brings the wrong kind of attention.
Labeled pariahs.
The feds had no choice but to shut us down.
And shut us down they did.
But like any intrepid jawnz peddler would.
We took that shit underground.
And got more corrupt than ever.

As a young G, I became a runner.
It's a typical tale.
That ain't that typical.
If you ain't a typical blogger.
Sneaking dub monks across borders.
Makin' deals with the devil every day.
And deals with competitors.
Sometimes both.
Speakeasy trade shows.
A business card?
Fuck that.
Rotating passwords.
Hot dames.
Even hotter product.
Bootlegged private label.
Brewed and sewn in the basement.
Original gangsters straight hustlin'.
Slinging that lifestyle.
Fast and loose.
Before we even had a name for it.
Building the empires you see today.
Eddie Goodman the slick-talking hotshot.
Got in bed with Boss Bergdorf.
And a racket was born.

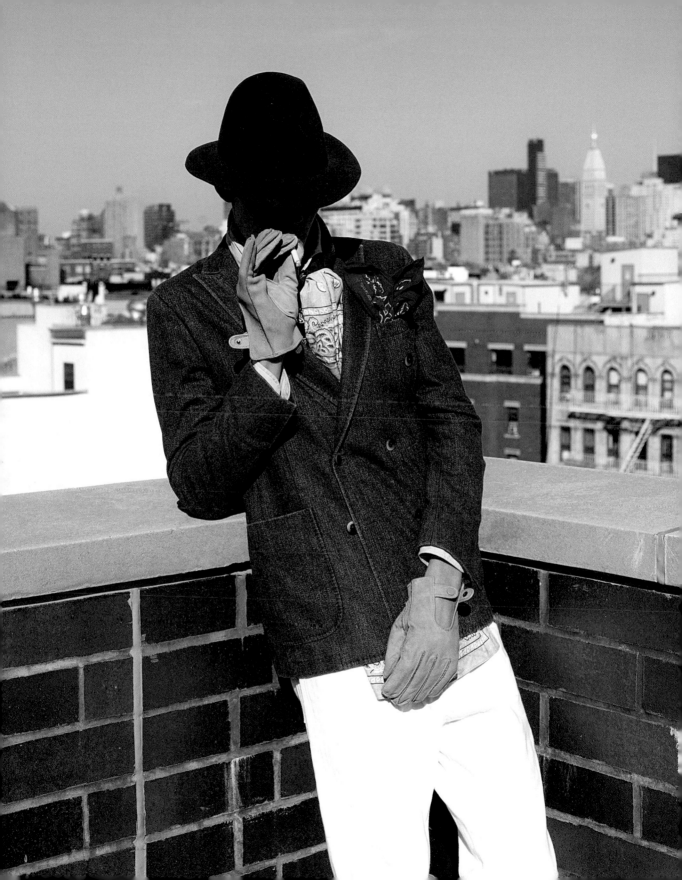

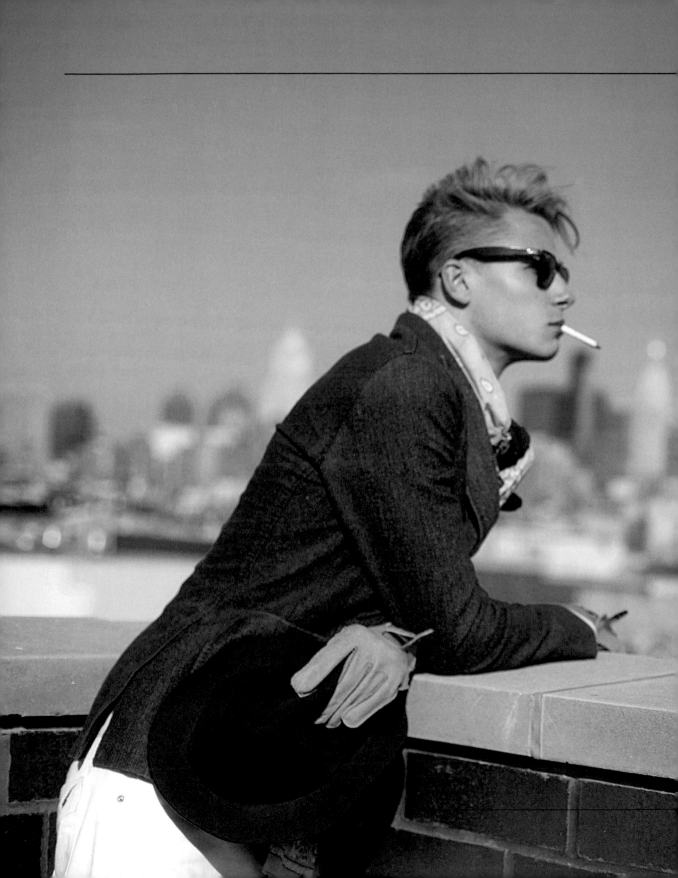

The Bloomie brothers.
Blunt Bavarian objects straight from
 the Lower East Side.
Salesmen by blood.
Sammy Lord and G. W. Taylor.
Hard-nosed immigrants from across
 the pond.
Hip with the broads.
Barney Pressman as deadly as he
 was entertaining.
Went straight to the people.
With a bit under the table of course.
"No bunk, no junk, no imitations."
Let's get one thing straight.
This lovefest y'all fools got going on today.
That shit was foreign to us cats putting our
 lives and reputations on the line.
Just to move a little steez to keep the
 people happy.

Just to keep a little food on our family's plate.
But the greed was still there.
And things only got worse.
And eventually it got bloody.
You aint seen shit 'til you seen a goon
 clapped in the cranial.
Just cause he was tryna push a crate full
 of button-downs in the wrong territory.
Peeps got more organized.
And as it usually goes.
As things get more organized.
They get more out of control.
So remember next time you try to dap
 me up in that sale section.
I've shed blood for this shit.
I've lost friends over this shit.
All so you can post up outside a
 fashion show.
Without looking like an asshole.
So excuse me while I pour out some
 Marcoliani.

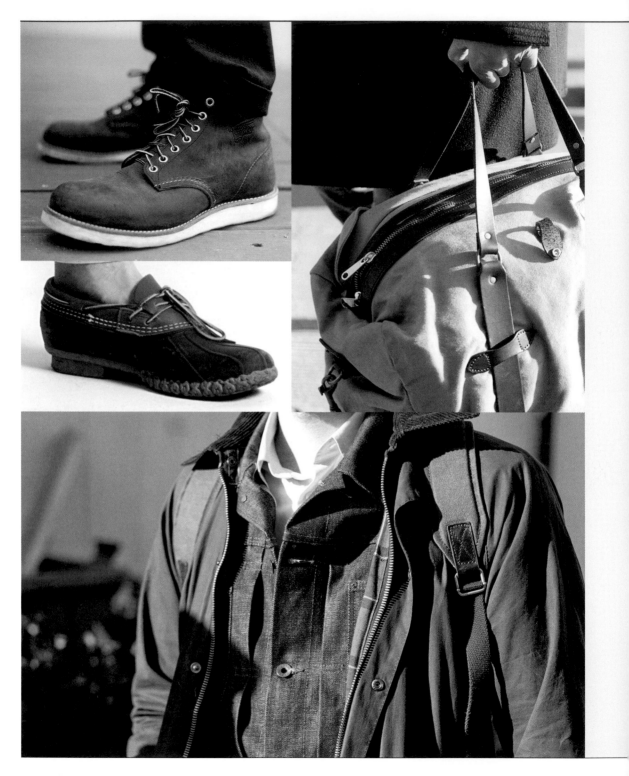

Heritage Brand

[**her**-i-tij-brand]

Heritage brands are those that through their storied history have gained an excellence par none in crafting durable, timeless products to outfit men for any and all conditions. The OGs. The heavy hitters. You know them well. A worn pair of Levi's (EST. 1073), a rumpled Brooks Brothers Oxford cloth button-down (EST. 1818), your dad's old Barbour jacket (EST. 1894), muddy L.L.Bean boots (EST. 1912) left outside the door after going on a walk with Charlemagne, your golden retriever (EST. Man domesticating wolves). These are the companies that for generations have been providing the products that make the sad, bleak existence of a human being slightly more bearable and even, on occasion, actually kind of badass. Being a heritage brand is not just a question of being founded in a pre-electricity era but rather a commitment to excellence that goes far beyond the products themselves.

These are clothes not just imbued with high-quality construction but with stories as well. Founded by an outdoorsman to equip hunters and fishermen for harsh conditions, a luggage crafter making cases for high society in turn-of-the-century France, the innovation of clothes for a new way of life in the American West, whatever the brand, men want a story and history they can connect to. The ideal heritage brand has history, struggle, and craftsmanship with a dash of innovation.

Wouldn't an old brand be stuffy and totally passé? In fact, in an almost anti-fashion stance, many menswear enthusiasts want products that defy trends to help balance out their wardrobes. Just as much as men want whatever is new and shiny, things with age are often even more important. Fine wine, brandy, vintage cars; most men won't even date women unless they've been around for eighteen years. With age comes character and distinction, and even with an epic lookbook and a feature on ACL (+10 heritage) most new brands can't even come close to passing muster.

Heritage brands have made a resurgence as of late. In reaction to the globalization of clothing production, buyers have turned their focus inward, and domestic factories have been heralded as bastions of their respective country's industry. With *outsourcing* a dirty word, in the modern international marketplace, provenance is king. Buying local is the new Parisian shopping spree. The "Made in the USA" tag has become not only a symbol of pride but, more important, also a new way for the menswear elite to both maintain their style dominance and "connect" to the common man. There is nothing more satisfying than knowing your three-hundred-dollar pair of Levi's based on a 1954 design will wear in to give you that authentic look of the twenty-dollar pair you saw your gardener in last week.

While the style world charges on to man-skirts and Savile Row × New Era collabos, these heritage brands stay in their lane. They keep making their same boring, reliable, and trustworthy products. Because at the end of the day, a pair of jeans or a jacket that comes with a Steve McQueen cosign will always be on point. ■

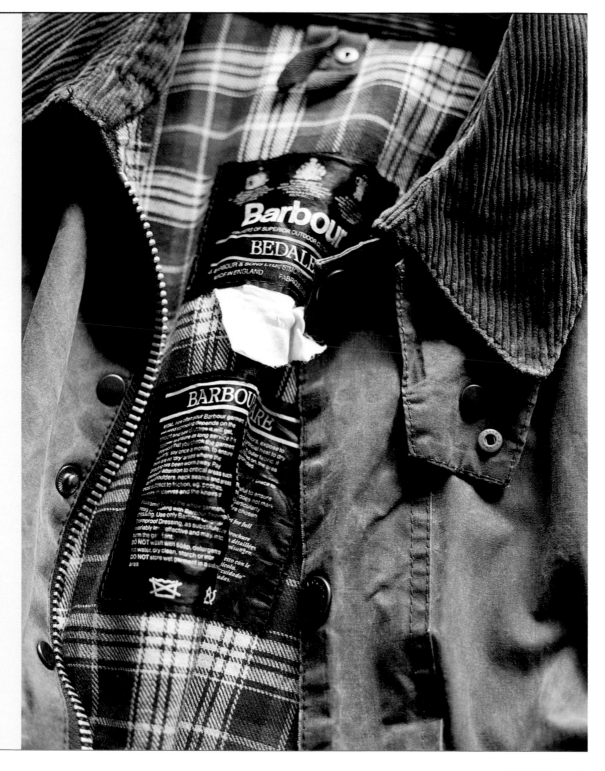

What happens to a man when he goes too far?
What happens to a man that wakes up one morning,
 and out steezes himself?
Walking down a SoHo street.
Filling up SD cards.
Crashing servers.
Like usual.
Caught my reflection in the lens of a DSLR.
Saw the face of God.
He said one word.
"Crispy."
The next twenty seasons flashed before my eyes.
Needed time to think.
The world wasn't ready for it.
Had to get away from it all.
Back to nature.
Iced out on Walden Pond.
Henry David Theezy in Red Wings.
Thornproof Wax Dressing in my stache.
Burnt orange chinos.
Taped seams.
Making Mother Nature want to start a Tumblr.
Too much style for one man.
Brought my girl along just to wear my second kit.
Steez Double.
I let her do the long shots.
Coming back to civilization in two years.
The Menswear Messiah.
So many followers.
All dyed-in-the-Woolrich Woolly Mills.

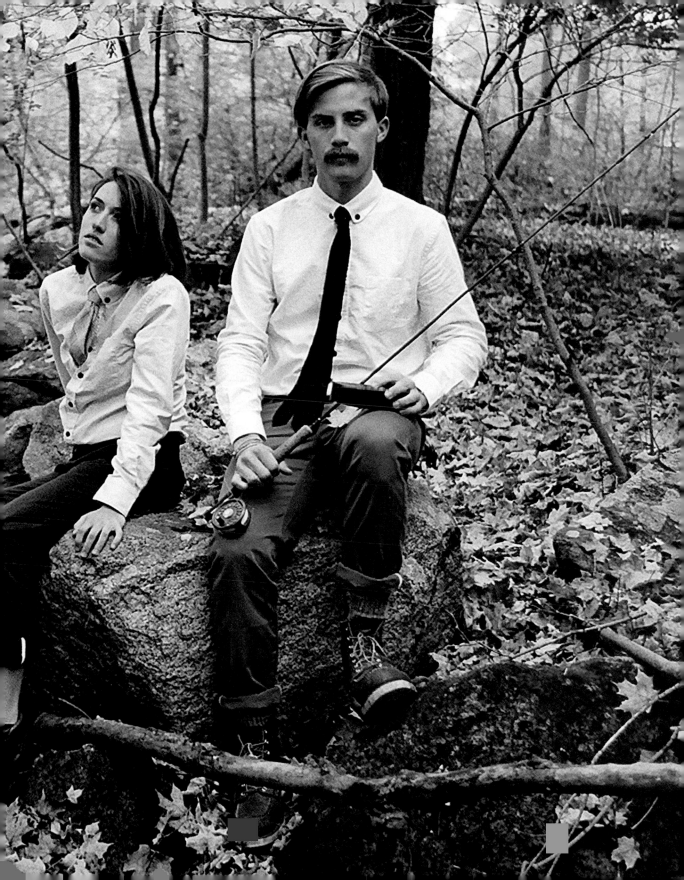

Two sides of the lens.
Janus in hi-res.
I pose.
He shoots.
Shutters bust.
Bloggers bust nuts.
Can a friendship be a collabo?
When I link up with my partna.
It's not just x's.
But alotta o's.
Photos on each other's dashes.
Mentions in each other's timelines.
Man jewelry like Pitti.
Rollies, pinky rings, and friendship bracelets.
Racks on racks on racks.
Warm embraces.
Flowers in our lapels.
Eyes to the horizon.
Dicks in our waistbands.
Finishing each other's sentences.
Like selvedge lines.
Bespoken handshakes.
150 manual operations.
Slap.
Slap.
Salute.
Bump.
Slap.
Bump.
Explode.

He keeps a point and shoot at my place.
Just in case he sleeps over.
Staying up late.
Coding each other's blogs.
Watching Redford and Newman.
Play cowboys and Indians.
Gigglin' 'bout the fashion photogs we like.
Arguing over Brucey Web.
His name scribbled on both our Moleskines®.
Can't wait to grow old together.
Watch you die.
On some UP shit.
Don't worry bro.
I'll spend that sponsored post srilla we
 saved up.
Fly to Firenze.
Scatter your ashes.
At one of Cuci's tea parties.
Hopefully none of it gets in the Prosecco.
But until the casket drops.
We makin' magic.
A single soul.
Wrapped tighter than that leather Caduceus.
I copped from Hermès.
Dwelling in two bodies.
I smile at you.
The flash goes off.
You smile back.
Then I get naked in the street.
And put on my next look.

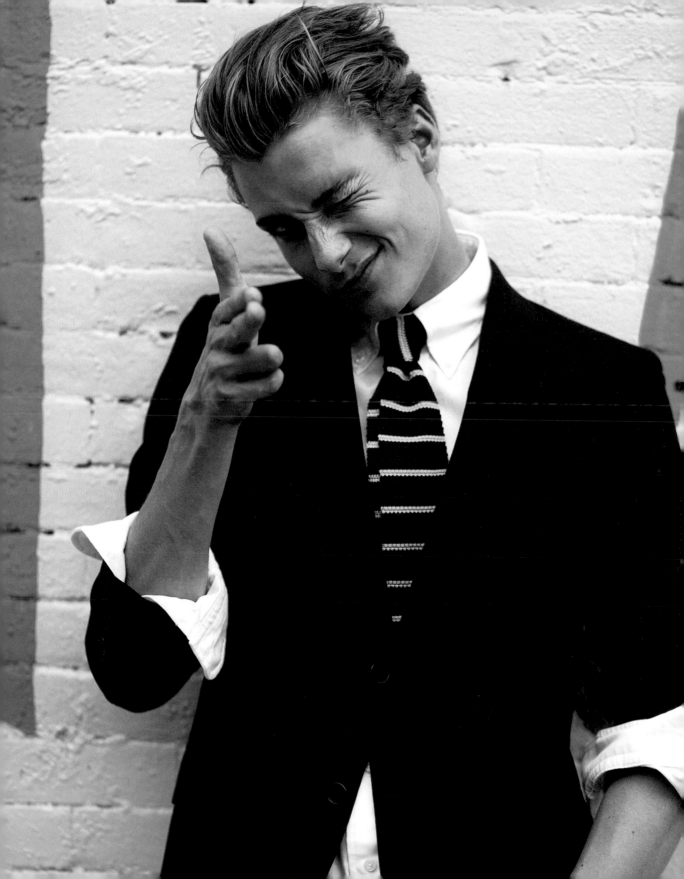

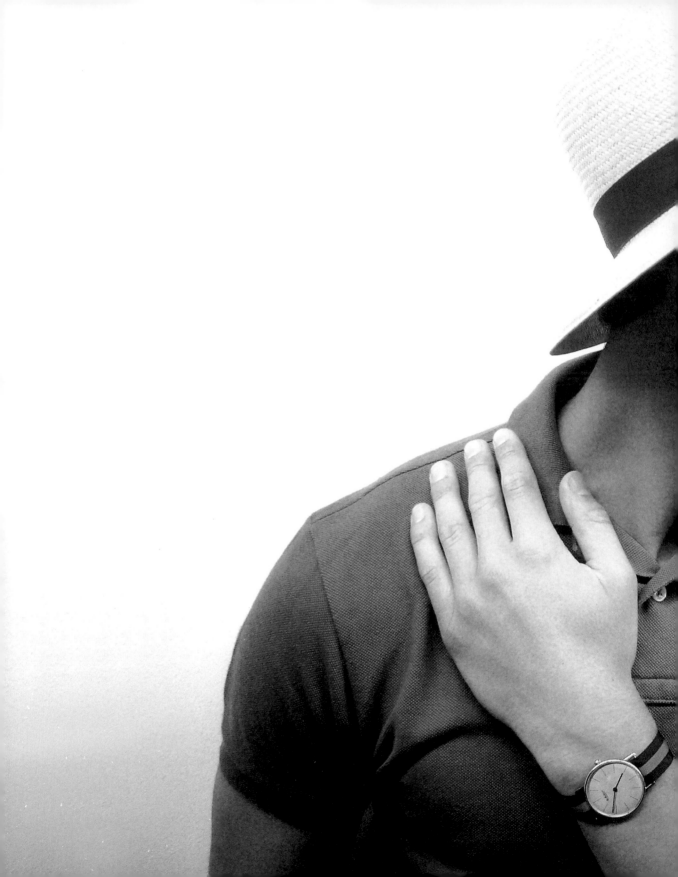

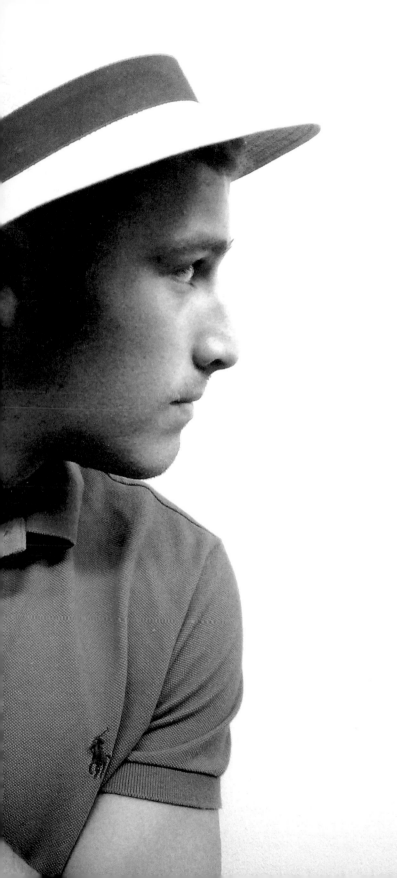

Take a memo, bro.

As the sun sets on this romance we've
 created.

Let us join hands one last time.

Grip each other tight.

Fuck.

Scratch that.

New memo, bro.

How can you look at yourself in the mirror?

Peacocking around palazzos like infants
 drunk on rotten breast milk.

No one is going to suck at my teat.

Fucking shit.

New memo, bro

I had no idea this was a team sport.

I had no idea we were tossing alley-oops to
 6th men.

Where were you when I was showering in the
 locker room of style?

Goddammit, motherfucking shit.

New memo.

Since when do emperors fraternize with
 plebes?

You're supposed to get slain in battle.

While I revel in an orgy of silk.

GODDAMMIT!

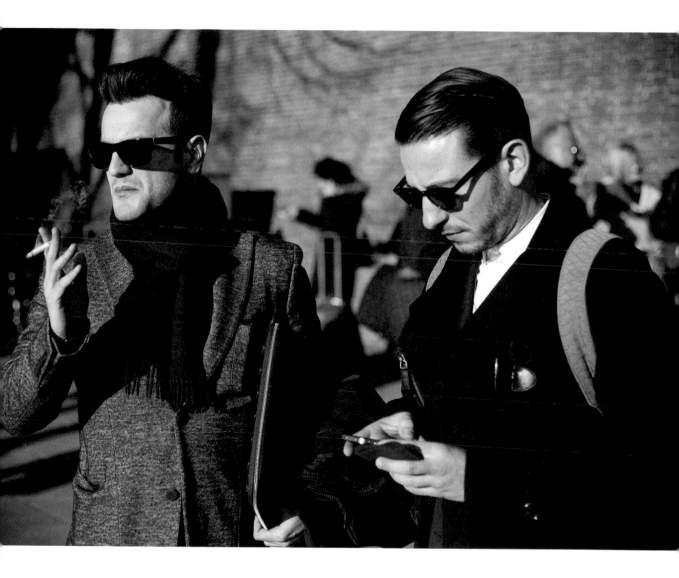

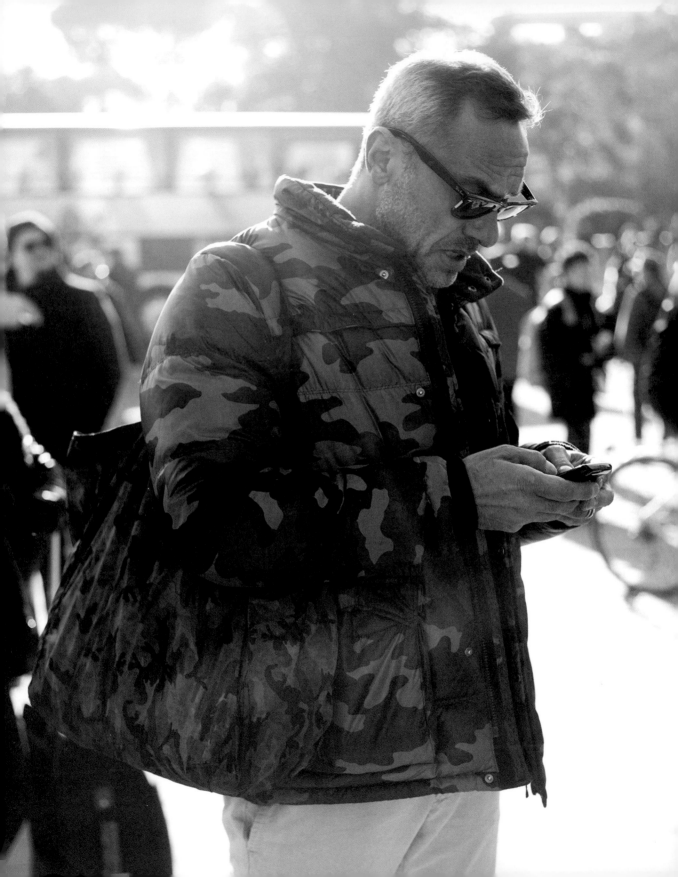

FROM: theboss@company.com
TO: company-listserve@company.com
RE: heritage is over
SENT: 2:36 PM 8/15/12

hey guys. best 2 years ever. we are fucking rocking this retail shit. quit patting yourselves on the goddamn back though. you think I ride this bike around the office for my health? hard left mother fucker—heritage is over

what? you say aldie collabos are selling like cray cray? i dont even know what the fuck cray cray means. you sound like my 12 year old niece. you thought the 6 million we spent on antique fixtures and steamer trunks were an "investment"? I'm a "fucking retail genius CEO" (Forbes). you think I got this far staying on trend? shit is mad played out. and if there's one thing i don't do it's played out. WHO THE FUCK FORGOT TO PACK MY FUCKING CAMO PANTS?!?!?! I spent this morning standing naked in my penthouse crying over our quarterly earnings. you do realize that our stock price has only doubled since I took over? do you know what people are saying behind my back at my monthly book club? you know, the one whore we burn first editions. I am totally fucked, ergo we are totally fucked, ergo grab the nearest taint and hold on tight. we will not be left in the dust that I mandated coat the floors of our brick and mortars.

if you don't think I'm serious, seppuku your whole everything. now that you fucking killed yourself I can move on. i fired all the buyers. i fired the designers too. yeah, that's right, our elite team that got us so far. each with 20 plus years of experience in retail. what does that sound like to you? borderline heritage right? fuck it. donzo. i just hired a bunch of tweens straight out of high school. you think a "fucking wizard CEO" (Bloomberg) doesn't have a popular niece? and who knows our customer better than our customer?! FUCKING GENIUSING RIGHT NOW!! I want fresh nubile babies that I can sculpt in my image. bloggers, tumblrs, and street urchins. (I'm halfway through a burned first edition of lord of the flies over here!) basically anyone who says "swag" is a VP. All our retail stores will now have built-in bunk beds for these young-lings. let them into your stores. let them into your homes. feed them. your life is now a retail concept. deal with it.

the market research team says that no one is ready to spend 3K on a boiled lamb leather zip jacket or a technical parka using artisanal plasticine trims. they say heritage has legs and we have another 18 months of solid sales ahead of us. did market research predict the fucking hindenburg? or the fact my wife won't look me in the eyes during handsex? I don't think so.

you might be wondering about our customers. are they ready? of course they are fucking ready. they're our customers and they'll do whatever the fuck i tell them to.

maybe it's because I haven't slept in four days, but it's looking like a bright new future. shred all the paperwork! No more archives! Divorce your spouses . . . i actually feel really bad about this one guys, but our health coverage will be taking a sizable cut. We stand at the dawn of a new age.

tl;dr

i'm the boss. i shake shit up. don't fuck with me. I love my niece. heritage is over.

A complete library.
My design school.
My journalism school.
My business school.
Just because my knowledge arrives monthly.
Doesn't mean I'm not worldly.
"Global Rethink: Are Brands, Brands? Or
 Just China?"
"Cheers to Your Chopper: How a New
 Generation of Helicopters Allow for
 Maximum Party Flow"
"Think Tank Report: Brazil Struggles with
 Repercussions Surrounding Space-bound
 Anacondas"
My guide book.
To life.
To the life I want to lead.
To the life I dream about.
This is not a lifestyle magazine.
This is a briefing.
The best sashimi in the Helsinki airport.
The best midnight eco-spa in Hong Kong.
The best facial on Mt. Kilimanjaro.
The best concierge to the best concierges at
 30,000 feet.
This is not a lifestyle.
This is a briefing.
The crème de la crème
Brûlé on the best brûlée.
Soft power.
Hard spines.
Leaf through.
When you're a 9 to 5 CEO.
You only have time for one non-lifestyle
 magazine.

This is a briefing.
Start ups.
Game changers.
Start changers.
Game ups.
J-Pop.
All the best reporting.
"Briefing from Singapore: A Geo-Political
 City Survey Sponsored by the Tourism
 Board of Singapore"
"Brand Finland: How Many BlackBerrys
 Can You Bring to the Summit Table?"
"Forecast 2013: A Forecast of Forecasts for
 the New, New-Old-Media Presented by
 Rolex"
Retail space cum cafes.
Cafe cum boutique hotels.
Sustainable roof garden cum dumpsters.
This is my life.
This is my world.
This is not a lifestyle.
This is a briefing.
New sectors.
Old money.
New money.
Old sectors.
Smooth Jazz.
All for only £10.00 a month.
But hey, the podcast is free.

MONOCLE —— issue 49. volume 05
DECEMBER 11/JANUARY 12

MONOCLE —— issue 48. volume 05
NOVEMBER 2011

MONOCLE —— issue 47. volume 05
OCTOBER 2011

MONOCLE —— issue 46. volume 05
SEPTEMBER 2011

MONOCLE —— issue 45. volume 05
JULY/AUGUST 2011

MONOCLE —— issue 44. volume 05
JUNE 2011

MONOCLE —— issue 43. volume 05
MAY 2011

MONOCLE —— issue 42. volume 05
APRIL 2011

MONOCLE —— issue 41. volume 05
MARCH 2011

MONOCLE —— issue 40. volume 04
FEBRUARY 2011

MONOCLE —— issue 39. volume 04
DECEMBER 10/JANUARY 11

MONOCLE —— issue 38. volume 04
NOVEMBER 2010

MONOCLE —— issue 37. volume 04
OCTOBER 2010

MONOCLE —— issue 36. volume 04
SEPTEMBER 2010

MONOCLE —— issue 35. volume 04
JULY/AUGUST 2010

MONOCLE —— issue 34. volume 04
JUNE 2010

MONOCLE —— issue 33. volume 04
MAY 2010

MONOCLE —— issue 32. volume 04
APRIL 2010

MONOCLE —— issue 31. volume 04
MARCH 2010

MONOCLE —— issue 30. volume 03
FEBRUARY 2010

MONOCLE —— issue 29. volume 03
DECEMBER 09/JANUARY 10

MONOCLE —— issue 28. volume 03
NOVEMBER 09

MONOCLE —— issue 27. volume 03
OCTOBER 09

MONOCLE —— issue 26. volume 03
SEPTEMBER 09

Betwixt cobblestone alleyways and corner
 bistros is where you'll find me.
Manning the fresh cave.
The fortress of steezhood.
The league of extraordinary bloggers.
Who curates the curators?
Storefront looking all nondescript and shit.
Walk in wearing dad jeans and Foot Locker
 New Ballys.
Walk out wearing selvedge overalls and
 Japanese New Ballys.
Turning lames into sart superheros like
 it was my fucking day job.
This is my fucking day job.
Hot in the streets like J.Crew.
But with less collaborations.
Out of your size?
My bad, yo.
We don't stock anything.
Besides vintage stools and negative space.
You want some white paint?
Benjamin Moore for Engineered Garments.
I can sell you an aesthetic.
Redeem for $150 worth of forum cred
 at a later date.
Looking epic is half the fucking battle.
What, you were expecting the Liquor Store?
Looking all T.G.I. Friday's with a bunch of
 shit on the walls?
Fuck outta here, son.

At least pretend you want to get next level.
Charging wack bloggers to snap pics of
 the shop.
Please check your Goog analytics at the door.
Along with that 2006 point and shoot.
That shit is old as fuck, homie.
Money on my mind.

Danner moon boots on my feet.
Inspiration ain't free, bro.
This is the sound of silence.
This is the sound of a Daiki cosign.
This is the sound of my wallet on swoll.

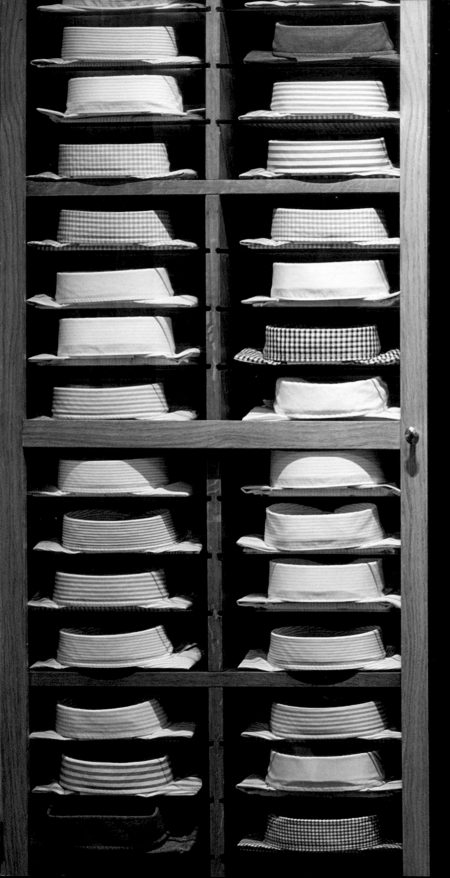

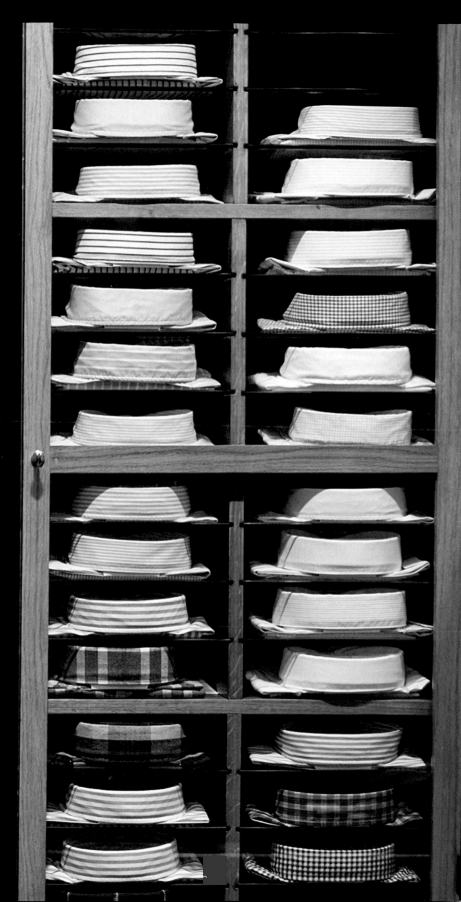

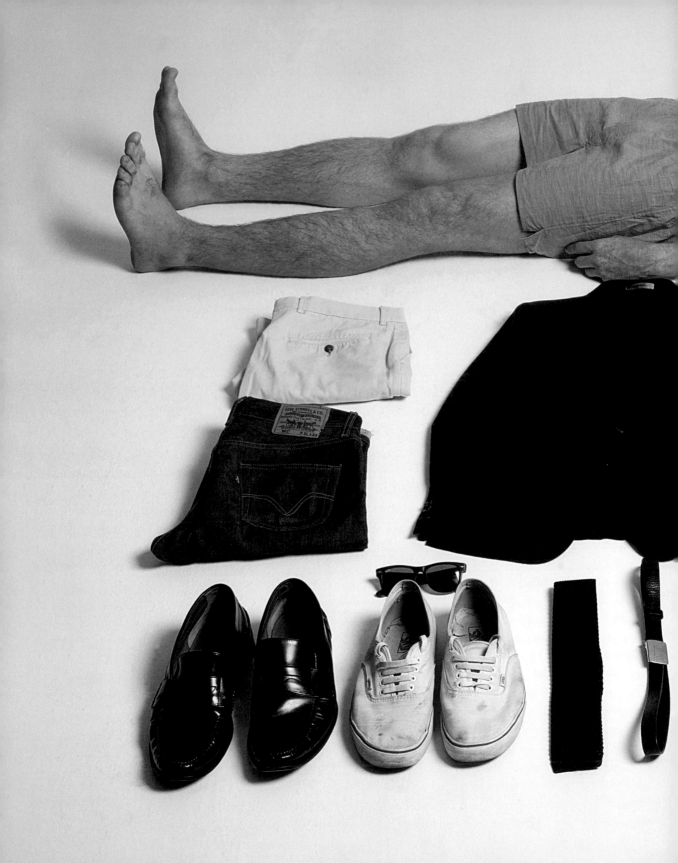

FUCK YEAH MENSWEAR'S
ELEVEN* ESSENTIALS

*Exactly one essential better than your average "Ten Essentials List."

No. 1

Oxford Cloth Button-Down

Flipping through my father's old yearbooks, drinking in his youth as he had drunk in mine, the wind was knocked out of me. Here was a young chap, with much more hair than he has now, with his entire life ahead of him. Before he broke his leg in the championship game. Before he knocked up my mother. Before he got sued for sexual harassment while working in the coal mines. Before the bitter divorce. Before he started to drink the pain away. This was a boy whose face was fresh with youth. A boy on the cusp of manhood. Here was someone whom I had never known. Someone I wished to meet. With his collar buttoned down, his sleeves rolled up, and the edges frayed, he was me. And I was him. I called out. No response. I called again. And again, no response. I exhaled just before tucking away the broken dreams of a broken man as I do an unruly shirttail.

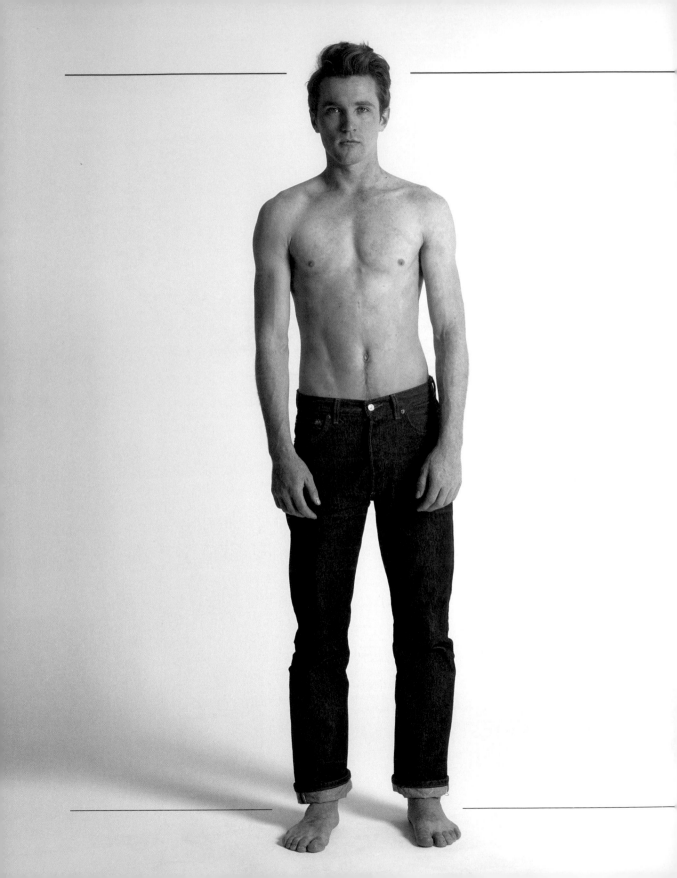

No. 2

Levi's

To think that something so perfect was made by the hands of mere mortals. The smooth warp and weft of cotton accented by the spice of copper rivets. Two swooping "V"s gently embracing themselves in eternal love upon the altar of your buttocks. The perfect jean. The final stage of an evolution that started with but a fig leaf. Pulling out into the sunset of a dusty road sprawled out before you. A wild one, a rebel. That one time, when you were ten and you galloped outside into the dew-soaked morn that smelled of barely ripe cranberries. Looking, grasping, yearning all around you. Every corner of your ever-expanding kingdom holding new secrets that were yours and yours alone. Knowing that one day an adventure so great would lie just ahead and change your life forever. Or, that one time you dry humped for two hours in the parking lot of a Burger King.

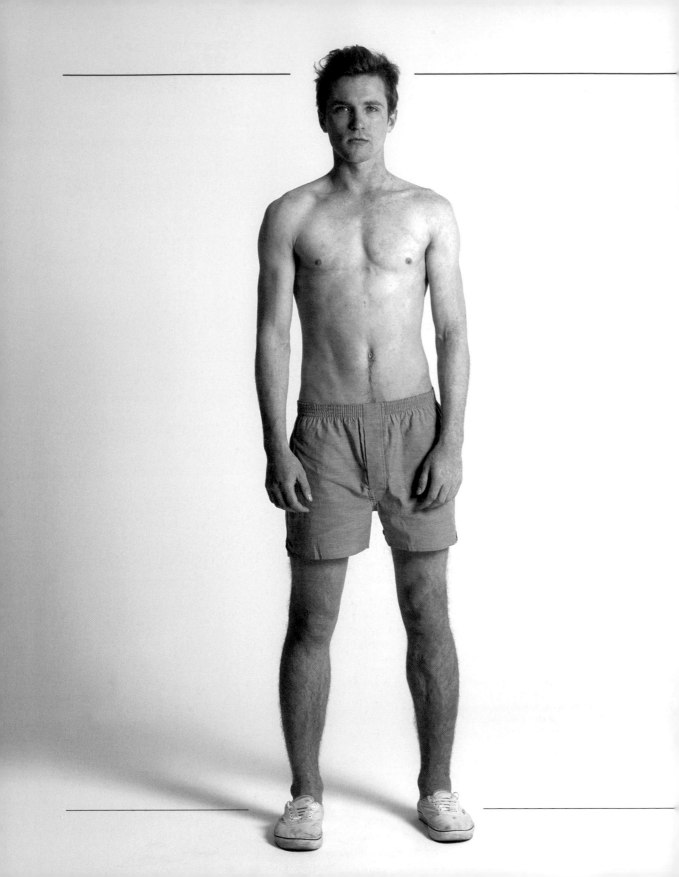

No. 3

Vans

It's the first day of summer and I know where my crew is meeting me. Sipping Icccs in our snap backs, we roll down the baking sidewalks, sunburnt, free, looking like some kind of beautiful flock of birds as the waffle soles of our shoes slap the pavement. Slap. Roll. Roll. Roll. Slap. I'm fourteen years old. That's my lifestyle. I'm pinballing through the universe. I'm a sunbleached cosmonaut. My shoes are untied. I'm in a metaphysical space zone, man, and I'm falling back up to the surface of the pool as I lipslide around the edge of the bowl. Me and my crew, we're reckless in our abandon. I'm standing at the top of the hill, I'm alone now. My face painted with chalk as I scream into the desert.

No. 4

Navy Knit Tie

The first time I gently knotted up my double-four-in-hand, I knew it was meant to be. My hands trembled with anticipation as the flowing silk moved through my fingertips like warm butter. As it slowly tightened around my neck I gave in, completely, madly, deeply to its awesome power. Its simplicity only rivaled by its textural complexity, the navy knit was destined to dominate the confines of my tie rack. I've since burned all my other neckwear and have held steadfast in my commitment. My bond is eternal. My love is unwavering. Often, while alone, I slowly wrap myself in its delicious embrace. Tighter. Tighter. Tighter still. Then, I touch myself. Sweet release. Oh, sweet silky navy release.

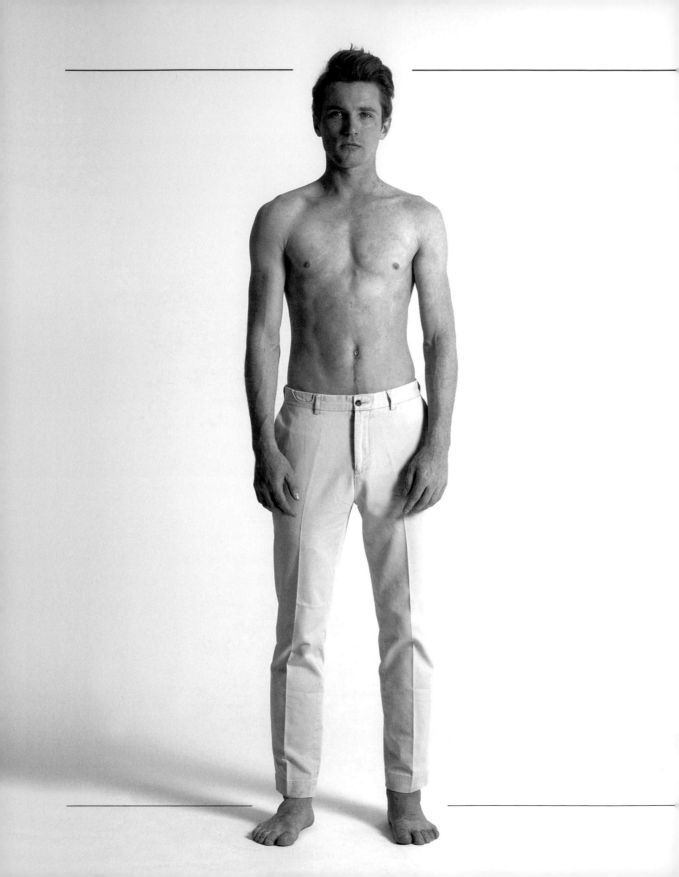

No. 5

Chinos

Dawn. Looking out through the bay windows, I slipped off the bed and into my chinos. Crisp yet casual, their perfectly muted khaki color reminded me of summers spent along the water at my uncle's in Nice. The French girls in their colorful dresses we used to chase down the boardwalk, our bare feet pounding on the planks. When I returned years later, I finally caught one. Now roguish in my double-breasted jacket and chinos perfectly creased and cuffed, I found her on the balcony. Sipping her cocktail she eyed me up and down. She approved. Now faded but still stunning in the morning light, that same pair of chinos brought comfort as I put a kettle of water over the open flame of the stove. I felt the hands of my mademoiselle slip into the soft cotton twill of my back pockets. "Adorbs" is what she whispered.

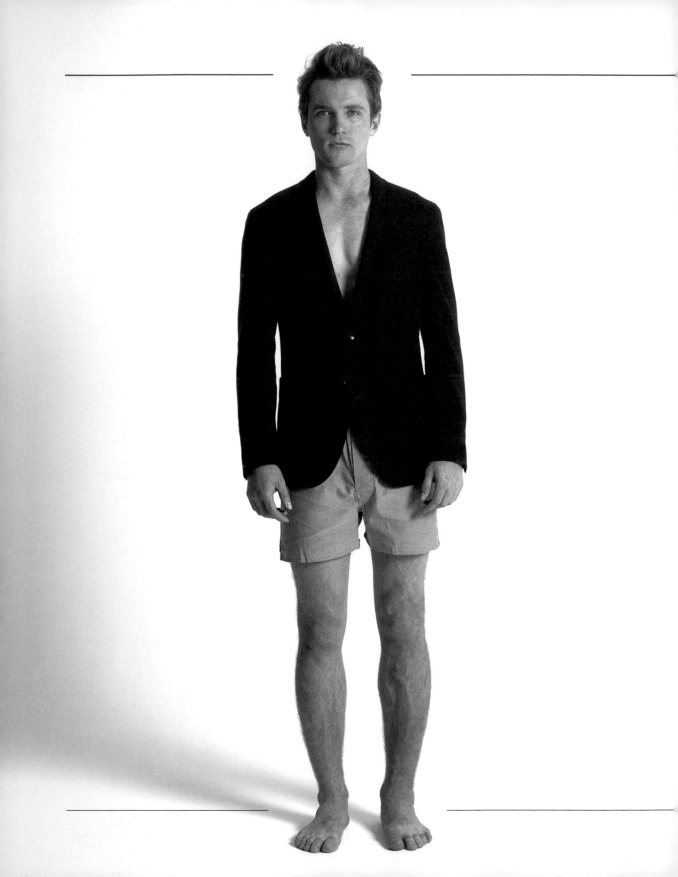

No. 6

Navy Sportcoat

SATs. Perfect score. Secret Society. Initiated. Graduation. Summa cum laude. Job interview. Stock options. First date. Fucked her. Fucked her twice. Meet the parents. Glowing reviews. Sit down and have a serious discussion about having children. Triplets. Open house. Escrow. Mounting pressures. Handled like a mature adult. Rumors of layoffs. Bonus. Coaching Little League. Championship. Kids growing up before your eyes. Cry, but manly. Back nine. 5 handicap. Retire. Palm Beach. Grandchildren. Rhodes Scholars. Die a painless natural death. Buried in my navy sportcoat.

No. 7

Ray-Bans

While I started smoking at thirteen, my Ray-Bans have been my signature of cool since I was old enough to walk. They hid my tears when Charlene broke up with me in the 5th grade. They hid my tears just as well when Charlene broke up with me again in the 6th grade. And they hid my tears once again, years later, when Charlene delivered the heartbreaking news that my dear grandfather was mauled to death by a cougar while out traversing the Sierra Madres. Not just for blocking emotion, but for blocking the cruel rays from above, my Wayfarers have accompanied me everywhere the light shines on my adventures. Just remember, a gentleman only wears his sunglasses inside if he's crying.

No. 8

Engine-Turned Belt

No man wants to be caught with his pants down unless he means to. A good belt equals control to a good man. Control over his waist. Control over his rise. Control over his world. And no man ever ruled the world without feeling both secure and confident. Consider your belt the ruler of your pants. Consider the engine-turned buckle belt the merciful ruler of rulers. One who exhibits strength in his understanding. Bravery in his stone cold demeanor. Wisdom in his versatility. At the very least, we try to improve ourselves with each and every passing day. The right belt shall help us lead the way.

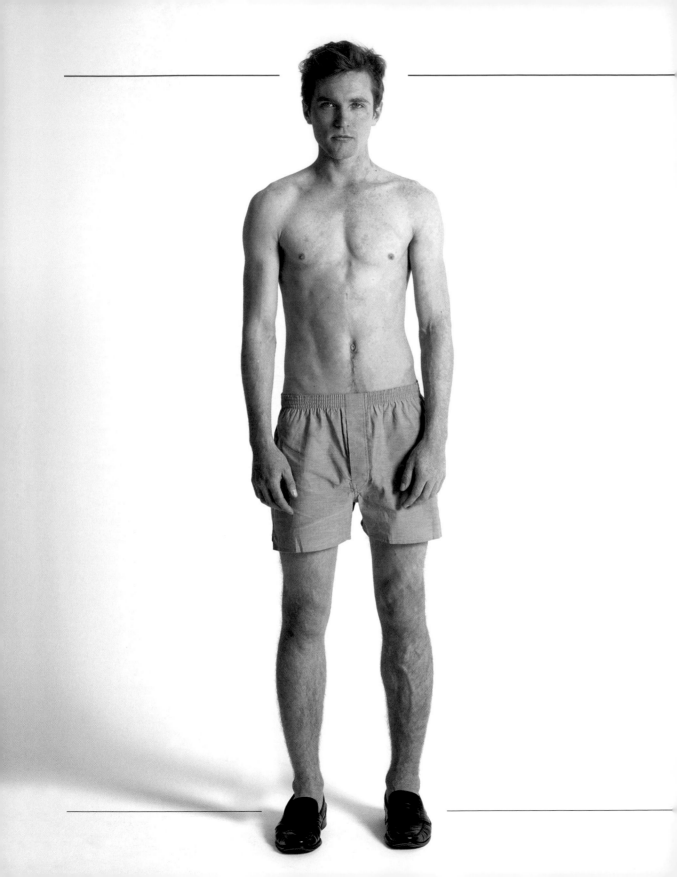

No. 9

Penny Loafers

P enny for your thoughts? How about two instead? You know that keeping your feet protected is a serious business, but also a serious investment. "How can I make that transition?" you ponder to yourself outside of your cobbler's daughter's window vainly whispering a sweet nothing up into the night for every three pebbles you toss. "Full scotch leather grain hand sewn to perfection," she finally coos down to you. You feign understanding, but your compassion is steadfast. A window may have closed, but images of tandem bicycle rides and obscure cheese tastings swell and contract in a glorious sepia. A great pair of shoes. A man about town. A cobbler's son-in-law.

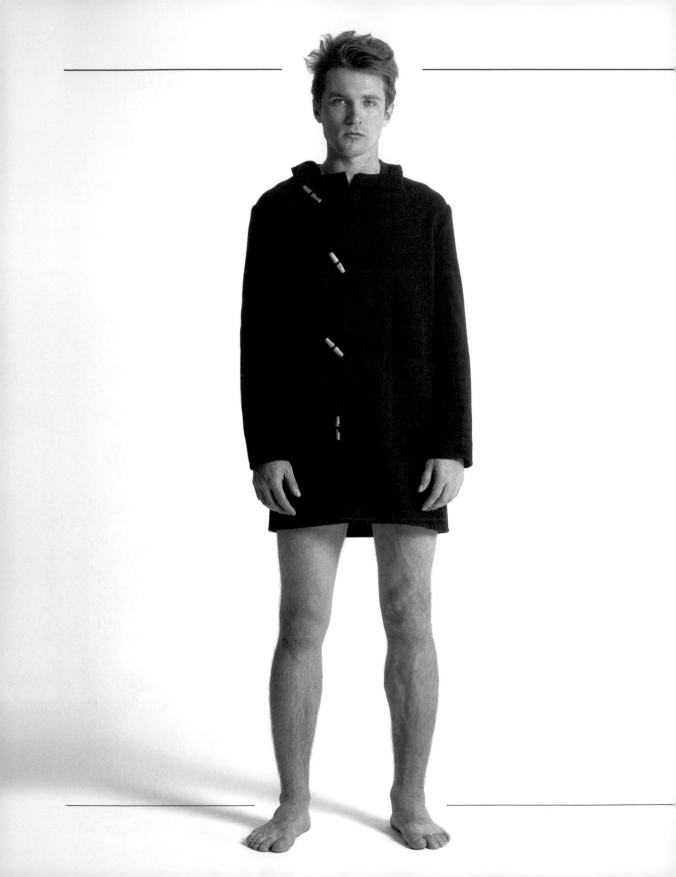

No. 10

Duffel Coat

The winter is a cruel mistress. Unsurprisingly, your mistress, also a cruel mistress. Why can't all affairs be easy? Why can't everything be as simple as the toggle on your coat? Stepping out into the freezing wind, you trudge slowly from the warm champagne-stained reasonably priced, hourly rated accommodations back to the brownstone where your wife and children sleep softly. It begins to snow as it does on Christmas Eve. Typical. The warmth of the thick Melton wool recalls that of two lovers' lingering tryst. She is an icy queen, but you love that she can make you feel. Something. Anything. You open the door to your toy mastiff jumping onto your legs in bewildered, wide-eyed excitement. Yes, Daddy is home. No, he doesn't have any presents. Those are all back in suite 602, twisted between soiled sheets and a lace negligee.

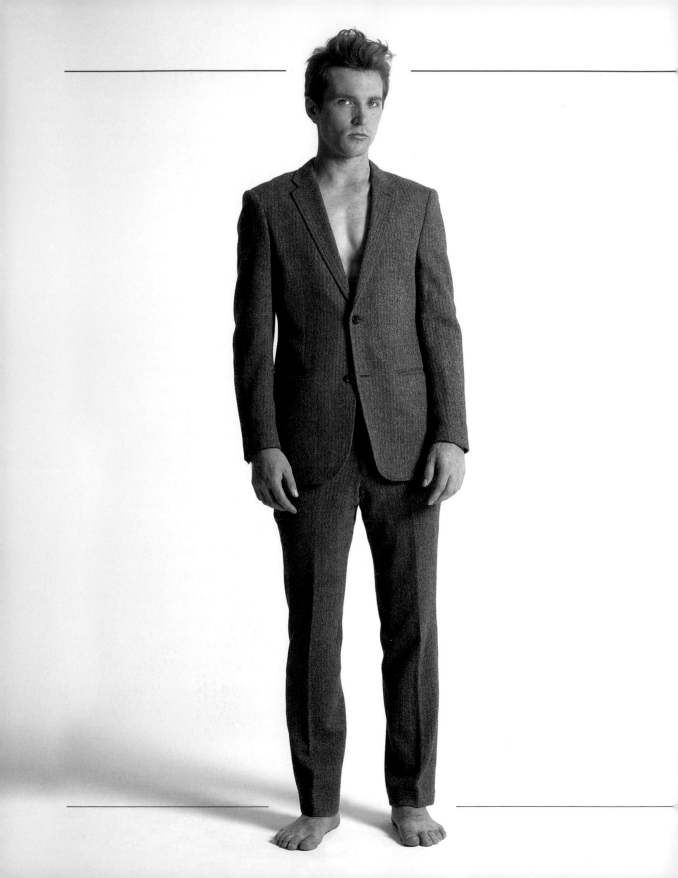

No. 11

Grey Suit

"The party's over," he said to me. "Fun and games are best left for the children." "Shape up or ship out." It was time to join the ranks. Time to join the drones. Time to don the uniform. I resisted at first as best I could. There was so much left I hadn't done. Tour with my band. Finish my collection of short stories. The only time I had been to Europe was during my semester abroad. At the very least, what was to become of my recreational drug habit? The days turned into more days, which somehow kept turning into days. And here I was. He gallantly swept his tassel from one side to the next and looked at me as an equal for the first time. "The party's over" was all I said. It was all I could say.

We weep for dreams unfulfilled as monochrome clouds cry the tears of a thousand souls.

An unacknowledged beast.
Overlooked and misunderstood.
Underrated.
The swagged-out Grendel to these double-
breasted Beowulfs.
These bloggers pass me over.
Replace me.
Like a Hoodyear welted Dainite.
Who will tell my tale?
Who will write my story?
The true story.
To garner acclaim imma have
to Gardner this myself.
And you know what?
Fuck bespoke.
I'm hand poured.
Molded by the finest Italian craftsmen.
On some artisanal shit that would son
a roped shoulder.
Clowns sitting down.
Playing with their iPhones.
Look at pictures of themselves.
Sitting down and playing with their iPhones.
Something like.
Rick Ross wearing a chain.
Of Rick Ross.
Wearing a chain of Rick Ross's face.
But if these designers want to ride
my coattails.
Sit on my shoulders.
P. Smitty socks like dolloped acrylic
on a stone cold palette.
And call themselves crispy.
They can sure as hell try.

They don't have my attention.
My mind is back at Grotte della Cervara.
Planning next season.
Next decade.
Next geological period.
Lookbooks for the Steelozoic.
I can't front.
Lately I think things are looking up.
Maybe these kids finally figured it out.
Figured out how next level I am.
But these editors still run to see the latest
collections.
Don't fucking trip.
I've got style for all seasons.
Rain storm?
Herbs spending all day waxing their
Barbours.
I just holler at some Florentine hoodrats
who still rock Soaps.
Cause I've been here year after year.
With my ear to the street.
Watching trends go by.
Buyers playing style catch-up.
Pre-blog era.
Hold up, shawty.
You're gonna sprain something.
Swag isn't built in a day.
Rome wasn't built in a day.
But I fucking was.

I don't know how else to put it.
I've thought it over a great deal.
But, simply.
My lifestyle is fucking ridiculous.
I can't believe it.
I'm just too fucking awesome.
I woke up this morning in a villa.
That I bought.
With money I had left over.
From buying a first, much larger villa.
My wife sleeping next to me.
Looking straight photoshopped.
I met her at a runway show in Pari.
A runway show in which.
I was sitting front row.
She was walking for the House that
 Coco built.
Until she stopped walking.
In the middle of the show.
Came over.
And sat on my goddamn lap.
Just to chat.
Just to give me her number.
Just to whisper sweet nothings into my ear.
She said I looked like a baller.
Really?
Who does that?
Karl gave me a high five after the show.
My lifestyle is fucking ridiculous.
She shot a centerfold spread.
The day after she gave birth.
To our fucking fat set of twins.
It's stupid how hot she is.
Just plain stupid.
Wow.

My lifestyle is fucking ridiculous.
What's my job?
I honestly can't remember.
Sure, I'll look at a few emails every
 couple days.
On my phone.
Maybe send a funny .gif out to The Board.
If I'm feeling productive.
Actually, I'm pretty sure I just got promoted.
Again?
My lifestyle is fucking ridiculous.
Dropped 20 large at Lardini.
Is that something people do?
Just to make sure I have a spare wardrobe.
I'll store it on the PJ.
For those last-minute flights.
To private listening sessions on private
 islands.
To open houses in open-air palazzos.
To conferences I get invited to speak at.
Last time in Stockholm.
The theme was "Climate Change."
Don't know why I was even invited.
Maybe something to do with my job?
I talked for an hour.
About how sick the bezel of my rollie is.
Standing O.
I'm still getting fan mail from world leaders.
My inbox is flooded.
These are the issues I deal with.
Day to day.
My lifestyle is fucking ridiculous.

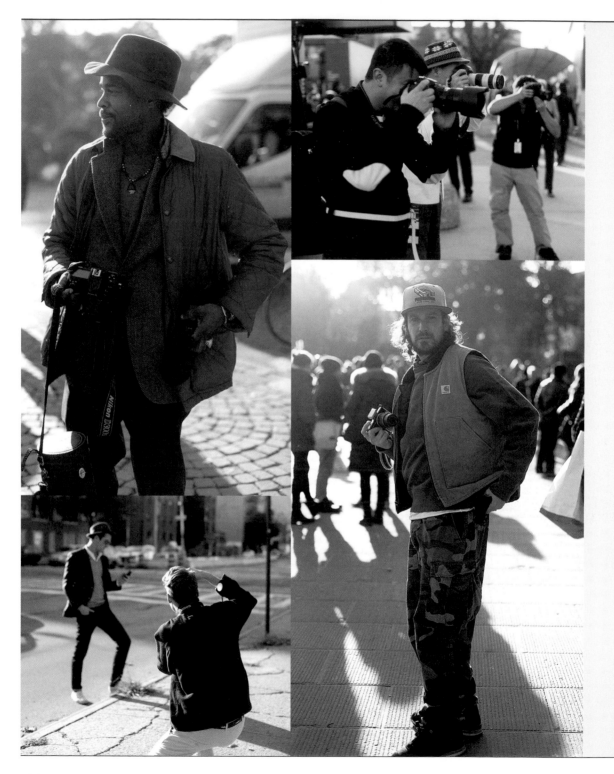

Street Style

[street-stahyl]

In today's fashion world, be it men's or women's, street style is a major factor. In fact, street style is the only form of blogging to have ever hit the mainstream, thus cementing both its importance and self-importance. From inspiring actual designers to creating icon mythology, the art of snapping portraits of those in the "real world" pushes the agenda of many, if not all, of the players in the fashion industry.

The origin of street style photography can be traced back to the work of Vivian Maier, who took pictures of poor people on the street in the mid-1950s. While it can be debated that she wasn't necessarily photographing her subjects based on what they were wearing, she was an early adopter of the art form. Interestingly enough, since no one cared about Vivian Maier while she was alive, we look to the work of Bill Cunningham when establishing the classic works of the street style canon. Most people are surprised to hear that Mr. Cunningham defined a genre without using a computer, but this is the truth. Mr. Cunningham's photos feature both fashion's high priests and "stylish" nobodies. This established the precedent of street style photographers mixing the demographics of their subjects. To this day, you cannot take too many pictures of famous people without being labeled a paparazzo, and a paparazzo is not allowed to be an "artist." On the flip side, you cannot feature only average people because then the fashion world will shun you for

lack of access. When thinking about the greatest street style photographers of our time, Bill Cunningham tops the list if only because he had a movie made about him.

For the most part, today's street style photographers are most likely bloggers. This means they will refer to themselves as photographers, but everyone else will refer to them as bloggers. They will have a website upon which they will display their photos in lieu of the standard photographer's "portfolio." Our time's most famous example of a street style photographer is Scott Schuman because he was the first to take Bill Cunningham's method and present it to an internet audience. This happened in 2005, which may seem recent, but was actually before things like Twitter and Facebook were invented. Scott has since branched out of merely blogging and now gets the steady commercial work a standard photographer would get. This has paved the way for a new generation of street style photographers to follow suit. These street style photographers can be found all over the internet with skills ranging from "worthy of selling out" to "Tumblr."

The genre of street style continues to grow by the day and has dominated the online fashion landscape as of late thanks to press mentions and the perfectly veiled amount of aspirational jealousy. Street style photographers can now be seen routinely at real fashion shows and events, even befriending many of the industry's snobbish elite. At the very least we must acknowledge, respect, and study this discipline as a viable route through which the traditional exclusive barrier of entry into the fashion world is lifted, even if ever so slightly. ■

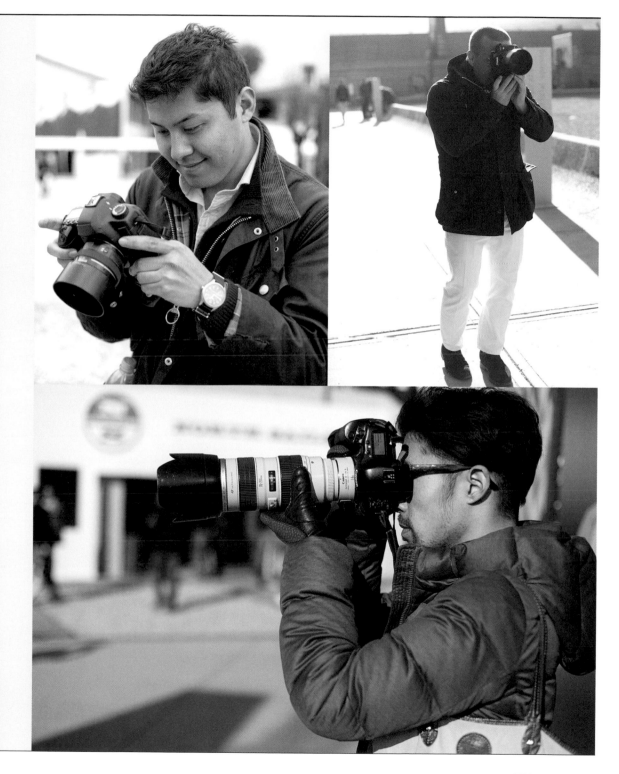

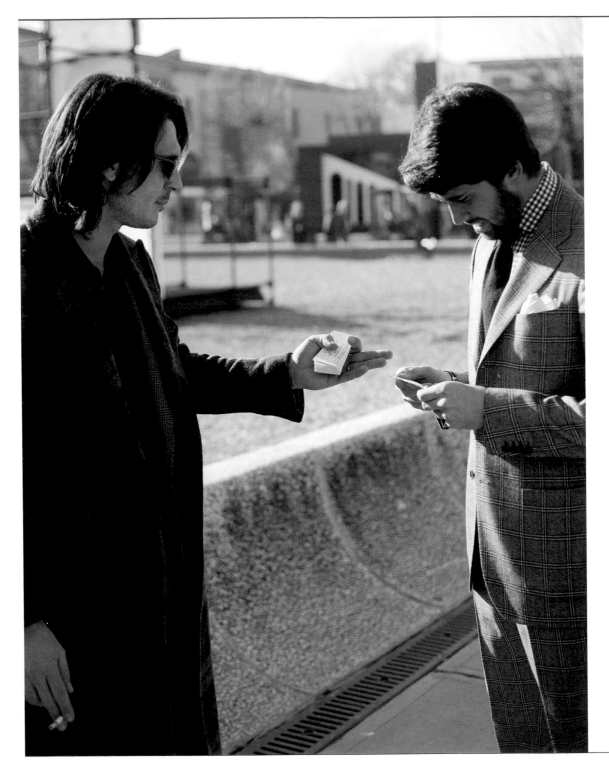

Hey, man.

Yeah, you over there.

You got a second?

I hate to bother you and all.

You look like a man of fantastic taste.

In fact.

You wouldn't even be here if you weren't.

But I've got to say.

If you'll excuse my candor.

You can be so much more than this.

I may look young, but I've been to this dog and pony show for countless seasons.

I've seen a ton of guys just like yourself walk these hallowed booths.

And you know where they are now?

Tagging rhinestone-covered jeans with a 20% discount.

You don't want to end up like one of those sad fucks, do you?

Of course not.

Didn't think so, you're a man of distinction.

Well, let me let you in on a little secret.

Take those silk knots out of your ears and listen up.

And listen good, my friend.

You know how people talk about that guy?

Yeah, well, I am that fucking guy.

Here.

Take my card and don't lose that shit.

I know you think you've got it all figured out.

They always do.

I see a lot of myself in you.

Wide-eyed.

Fresh meat.

The entire world sits just out of reach of your driving gloves.

Let me be the first to tell you.

You don't know shit.

And you're going to fail.

In an explosion of flaming knit ties.

But I can help you with all that, see.

Remember, I am that guy.

I am the guy that takes you to the next level.

I am the guy that shows you how to truly stunt on peasants.

I am the guy that shows you how to swing your dick like
 you own the place.

Looking at you I already know.

You're trying too hard.

You've got all the telltale signs.

Symmetrical tie knot.

Straight fold pocket square.

I mean, c'mon.

Relax for a change.

Let loose.

Feel the fucking breeze on your balls, man.

You know what?

Just stop caring.

Right now.

Do it.

Stop giving any of the fucks you've
 previous relinquished.

Try getting dressed in the dark.

You want to surprise the industry?

Well, first you have to surprise yourself.

Pull some dope vintage shit out of the trash.

Hell, have unprotected sex for once.

I'm not even wearing underwear right now.

Surprised?

Me too.

That's how you get that edge.

If you follow these easy steps.

I'm more than happy to welcome you
 to the next level.

Wait.

Did I just give you my card?

Sorry.

I think I blacked out, man.

Ok.

Lemme start again from the top.

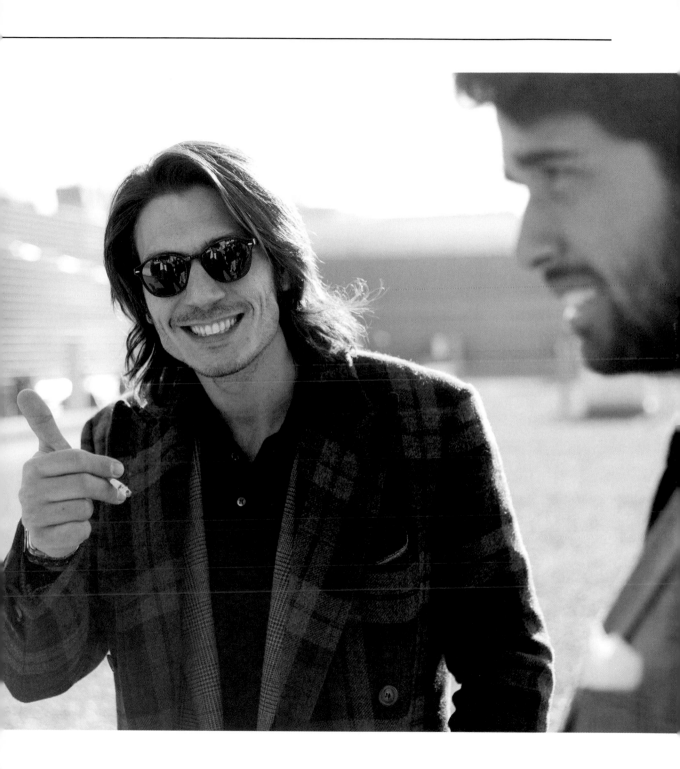

And now for some shout outs . . .

Shout out
to the keyboard gentleman soldiers. Shout out to the iPushers. Shout out to the point and shoot professionals. Shout out to the forum old heads who vote Republican. Shout out to the Yacht–club lookin' ass prepsters, whether they got racks or not. Shout out to the blog interns. Shout to the hypebeasters who think boat shoes are fancy. Shout out to the real talk retweeters, rebloggers, and regurgitators. Shout out to our checking accounts. Shout out to the hipsters with prescription monocles and gold rush facial hair. Shout out to the blueballed cats who sleep in their denim. Shout out to the steeziest street skeezers. Shout out to editors with real jobs. Shout out to the sample sale fiends who hit the sperm bank before the Cuci drop. Shalom to all the Jews who made this book possible. Shout out to all the fine-ass womens pretending they understand that menswear flow. Shout out to your online "magazine" (no shout outs to your online "shop"). Shout out to the heritage hitmen holdin' up factories. Shout out to actual interns. Shout out to the thrifters who think money doesn't buy style because they're straight poor. Shout out to the sith lord lookin' weirdos who pay homage to the young god. That's that transcendent shit we've been blessed with and we respect the birthright.

Shout out
to the hardbody dudes on the digital asphalt dripping with tasty steez and getting all crispy for a blogger. we fucks with you.

Lumberjack sluts and French sailor–lookin' ass mustachios.

Junya paper dolls.

Rugged boy swag.

Defying the physics of just how long dickriding is humanly possible.

If I had a nickel for every one of y'all.

I could buy us a round at The Rusty Knot.

Hold up real quick.

Let me hop in my DeLorean and meet you.

Back in F/W 2009.

Timeless style has never looked so vintage, brah.

When Ben Sherm bites your steez.

It's a telltale sign.

That you're wack as fuck.

See, I'm in the future, son.

Going hard in Milano.

Me and Righi.

Eating rice crispy treats.

Shopping for washed jeans.

Comparing notes.

Neapolitan wizard committee.

On some Fantasia shit.

The sorcerer's apprentice.

Casting sart spells on you weirdos.

With bogus ass facial hair.

By the time you're ready to Bunyan with the big boys, we'll be long gone.

On some next level soul patch shit.

Probably.

Post-pro athlete secondary sex characteristics.

Straight razor on these hoes.

Throwin' Euros in the air like we don't give a fuck.

And not shaking hands with any of y'all.

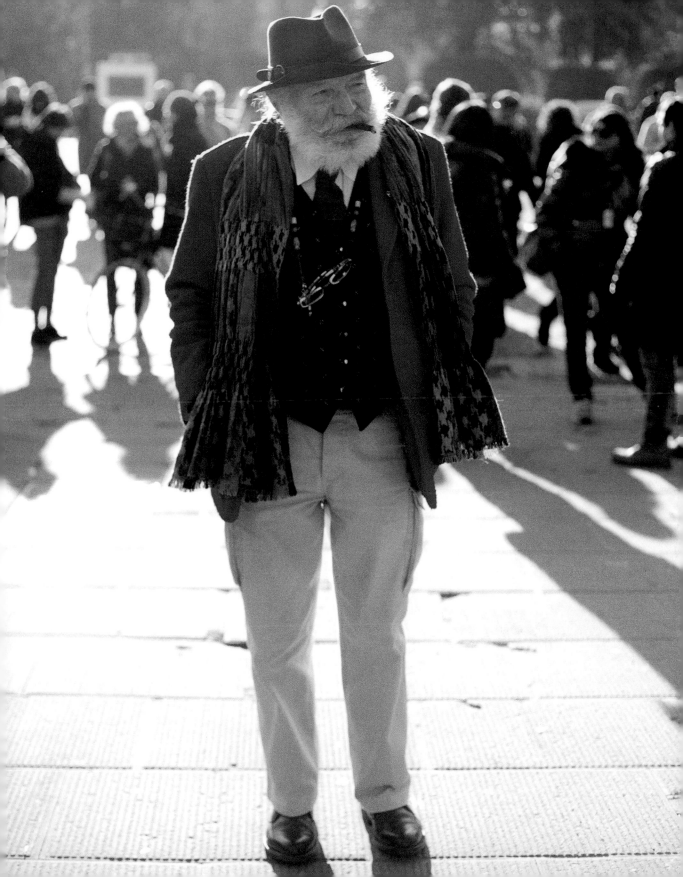

SUNDAY SUNDAY SUNDAY!

One time only.

Steezy Knievel.

The man with no fear!

The man who defies death!

The man with great taste!

WATCH!

As he breaks in a pair of 36 oz.

DENIM!

No man's crotch has lived to tell the tale.

WATCH!

As he ties a triple four-in-hand knot.

BLINDFOLDED!

The rawest silk from the far reaches of the Orient.

WATCH!

As he irons his shirt for his date with his beautiful assistant.

DINNER AND A MOVIE!

Creases be damned.

WATCH!

As he walks across burning coals.

IN DOUBLE MONKS!

Both straps unbuckled.

PARENTS!

Leave your children at home.

This is not for the faint of heart.

His only regret is that he has one life to give.

FOR MENSWEAR!

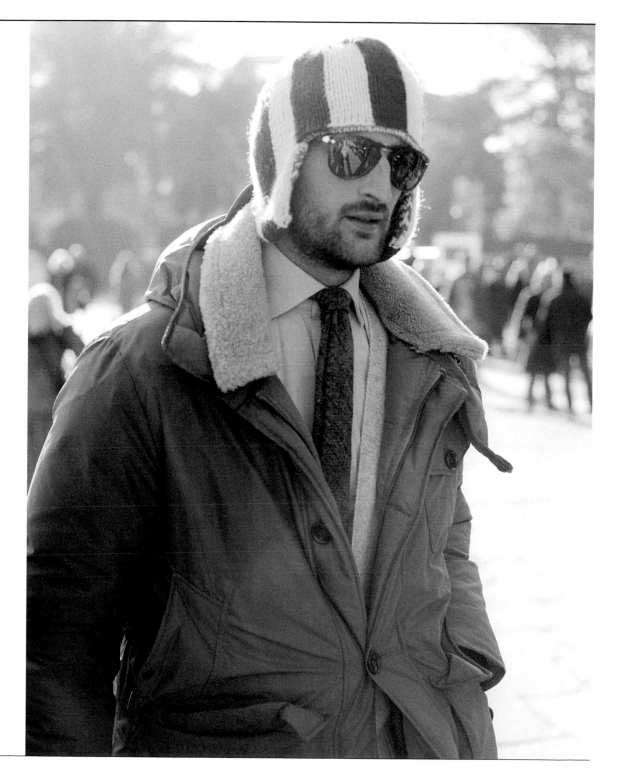

Murderous on purpose

Ya'll bloggers fucking heard this

Herbs still on Wordpress

You nervous

Got secret with my forts

And my fucking service

Pitch a tent on the game

Cause it's a fucking circus

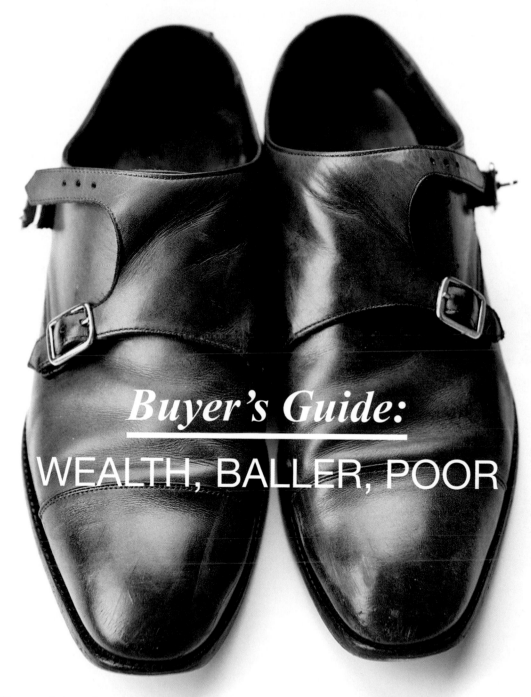

Buyer's Guide:

WEALTH, BALLER, POOR

For each item in your wardrobe, there are clearly defined tiers—wealth, baller, and poor. Where do you stand? Godspeed if you find yourself in need of an upgrade.

SHIRTING

Wealth—Finamore

Baller—Gitman Vintage

Poor—Brooks Brothers

NECKWEAR

Wealth—E. Marinella

Baller—Drake's

Poor—Tie Bar

POLOS

Wealth—Dead stock Lacoste

Baller—Band of Outsiders

Poor—The Gap

TROUSERS

Wealth—Michael Bastian

Baller—Incotex

Poor—J.Crew

SPORTS COAT

Wealth—Isaia

Baller—L.B.M. 1911

Poor—Howard Yount

SWEATERS

Wealth—Brunello Cucinelli

Baller—J. Press

Poor—Cosby

DENIM

Wealth—Momotaro

Baller—RRL

Poor—A.P.C.

SUITING

Wealth—Savile Row Bespoke

Baller—Thom Browne

Poor—Uniqlo

LEATHER JACKET

Wealth—Rick Owens

Baller—Schott

Poor—Members Only

WATCH

Wealth—Rolex Submariner

Baller—Seiko Dive Watch

Poor—Timex Easy Reader

DRESS SHOES

Wealth—John Lobb

Baller—Alden

Poor—Allen Edmonds

BOAT SHOES

Wealth—Quoddy

Baller—Sperry

Poor—Barefoot

SNEAKERS

Wealth—Lanvin

Baller—Common Projects

Poor—Vans

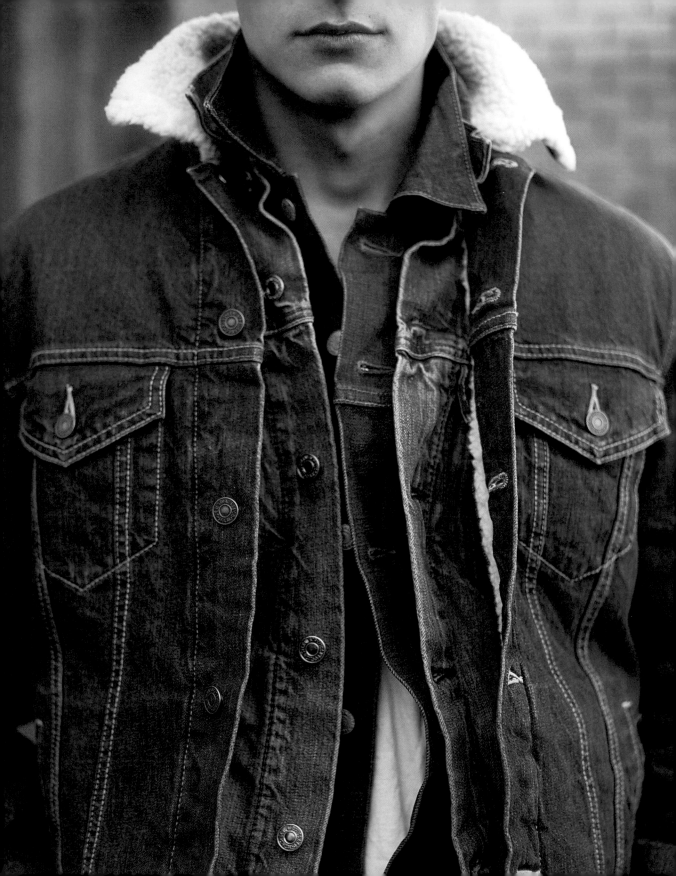

Truck wit me.
I call the shots.
Cause we live in denim.
And that shit fades a lot.
Fitzy once said.
Dress for the youth of your generation.
The critics of next season.
And the bloggers of ever after.
I said,
Why not all three?
Style Cerberus.
My body.
A manifestation.
An embodiment.
Of dope Givenchy screen prints.
Truck wit me.
The thing about types 1 through 3.
Is that bitches can rock 'em too.
Stay versatile.
Heritage hermaphrodite.
From raw to washed.
And back again.
Truck with me.

Three layers deep.
I am the core.
My shell.
Protects and warms.
How many licks?
Truck wit me.
My pop's pop once told me.
When the sun arches back.
On its old ways.
You stay golden.
You stay golden.
So I put on his jacket.
Then my father's.
Then mine.
Generations intertwined.
Histories converging.
Souls entangled.
Out I stepped.
Into the light.
Based.
With an exponent.
To the power of three.
Truck wit me.

Maxed out.
Flexing on levels.
Previously known only to string theorists.
And Jermaine's jeweler.
Could claim some shit.
Could spit a couple lies.
A blackout.
Possession by demons.
Fugue statin'.
But I was there.
I had my wits.
I did it again.
I blew that paper.
I binged.
Hard.
Don't give a fuck.
Felt so good.
Lyin' bout, "I'm so rich with my wardrobe."
The chronicles of my weekend.
I'm tryna see this Louis.
Can't say I woke up finna pop tags.
But found myself south of Houston.
Copping Fair Isle socks with my partna dem.
Someone grabbed some thin-wale cords.
Homie looked great.
Bounced out the store.
But it was too late.
I faked a call from work.
Part ways.
Doubled back.

Had to buy up that pair of boots dangling
 from their laces.
Calling me.
Tempting me.
Whispering in my ear.
Cordovan sirens.
Waiting to be broken in.
Like the one-month-old pair already on my
 feet.
"Weren't you just in here?"
"Pssh, nah."
I hand over my AmEx.
Plastic still warm from the first cashier's hands.
Next thing I know I'm arms deep in a pile
 of Aran knits.
Trying out exotic moisturizers and toners.
Stacking fishtail parkas.
Like they fishscale.
Picking up steam.
And a brand-new steamer.
A lifetime later.
I'm back at the crib.
Floor covered in bags.
Spare buttons rolling everywhere.
A shit ton of those little plastic joints.
Time to purge.
See how much I can flip on the forums.
Last week's haul hanging over my head.
Gotta move these units.
So the cycle can start again.

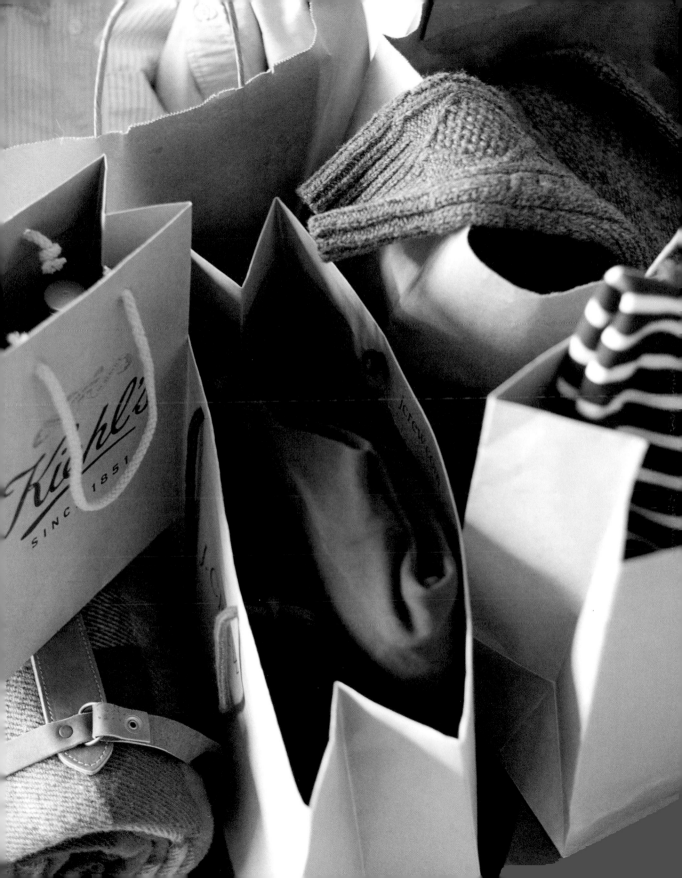

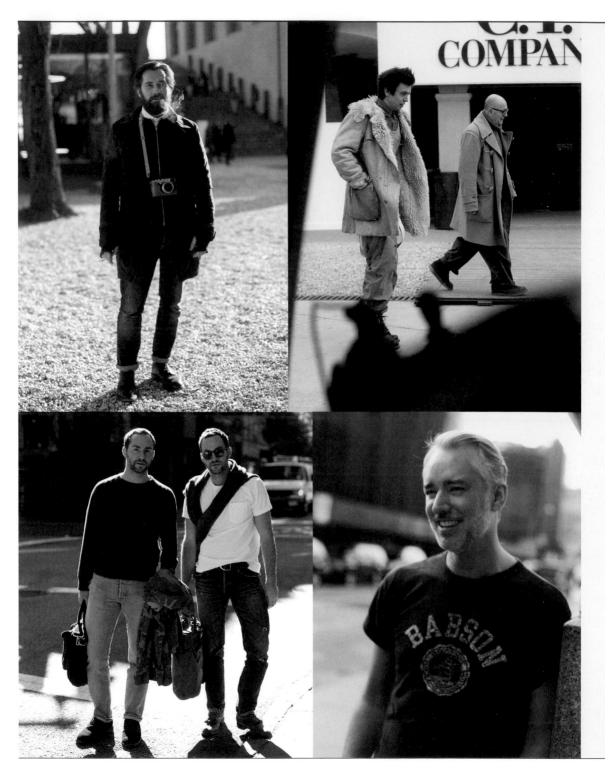

Designer

[dih-**zahy**-ner]

Sitting alone atop the fashion food chain is the designer. They are the visionaries. They are the creatives. They are the wind beneath our sartorial wings. Without them we would have nothing to wear. And without us, they would probably just be making clothing for themselves as many of them do. But how does one become a designer?

Most designers can probably trace their love for clothing back to their humble beginnings. A select few may recall their not so humble beginnings, but for the sake of this, let's remember a collective modest childhood. Mom and Dad may have been in a similar line of work. "I remember stealing her needle and thread to play with, for she was a seamstress." "He would come home very late at night, after most of us had finished supper. As he sipped his tea by the fireplace, I would fall asleep watching him rub his hands, for he was a cobbler." As children, designers most likely show flashes of their future profession. Some may even exhibit the qualities of a prodigy foretelling to everyone in their immediate vicinity that a star is being born. Now, this is where the path for many designers becomes complicated.

A designer's pedigree can take many forms. The lucky, encouraged few will enter proper institutions that will teach them their preordained discipline. Grand academies and universities throughout Europe will nurture their skills and, most likely, propel them forward. Less grand-ish colleges on the East Coast of the United States will attempt similar feats. But schooling is not

for everyone. Some of our budding designers will head right into the field. In days of yore this might mean an apprenticeship. Sometimes locally and sometimes far, far away from home. These days it's more likely to find a future designer working retail. Regardless of how traditional this education is, the designer will use this experience to hone his or her skills, find an identity, establish a pedigree, and attend some parties.

Where designers ultimately find work in their namesake career is hard to say. They may start their own eponymous line. They may go work for the eponymous line of someone else. They will all work for brands, both big and small. They will work for some of the most storied fashion houses the world has ever known, and they will work for some of the most pathetic mall brands the world has ever known. They will experience success and failures all in the hopes of one day running a business that affords them the ability to do whatever the fuck they want. At the end of the day, their careers are just like ours. Some are successful, while others fail. And while fashion often seems to operate outside the confines of reality, this is a truth that cannot be escaped.

Some of our designers may even become creative directors. This is often seen as one of the more attractive jobs to designers. In this capacity, the designer retains the chance to be creative and help shape the clothing of a company, while much of the grunt work is left to whatever less accomplished designers happen to be working for him/her. The technical proficiency of the creative director role is less demanding, which can lend itself to crossover both within and outside of the fashion industry. It is not uncommon to come upon a creative director lacking the background of the aforementioned designer. All creative directors are designers, but not all designers are creative directors. Now wait: all designers are creative directors, but not all creative directors are designers. Shit, never mind. ■

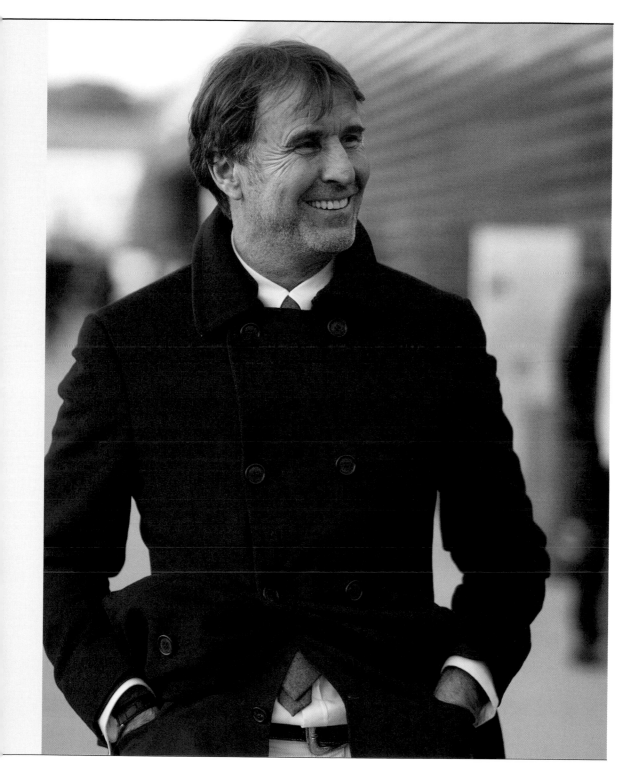

You think I give a fuck about chambray?
Just make sure you bring my critters, bitch.
Tryna get Waspy.
Lilly P belts with the guns still tucked
 in them.
Volvo station wagons with boarding school
 girls still getting smashed in them.
Prepset.
Prepset.
Prepset.
Fuck with me real quick.
Wreaking havoc all over town with my squad.
Rugby'd out.
Wrist on bling.
I think Coolidge gifted this shit to my uncle.
Whatever.
Bow ties.
Bow ties.
Bow ties.
They can load up if they want.
Aim atcha boy.
Take shots at the throne.
But these workwear goons should know.
I never leave the Cape without protection.
Patchwork Kevlar.
Unabashedly Teflon.
Cardigans.
Cardigans.
Cardigans.

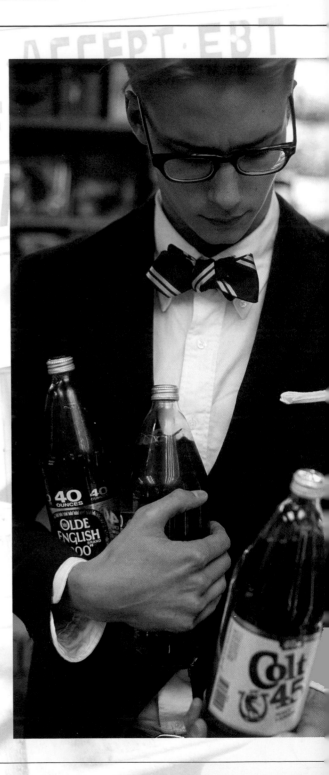

Got my hater blockers on too.
These frames make me look distinguished.
In case you didn't know.
I'm always watchin' that money.
New or old.
I don't give a fuck.
As long as I stay blowing cheddar.
This trust ain't gonna spend itself.
Boat shoes.
Boat shoes.
Boat shoes.
What do you know about the finer things
 in life?
When was the last time you sipped a
 nicely aged OE?
Told Jeffrey to pull up to the curb.
Keep the Jag running.
I'm just popping in for midday refreshments.
Lawn golf builds up a thirst.
Is it still called playing hooky?
When you attend class in a building named
 after your great-grandfather?
Repp ties.
Repp ties.
Repp ties.
Go to hell pants hand sewn by demons.
The same beasts.
Who haunt you.
When you flip through the pages.

Of that one Free & Easy.
Your cousin got you.
Because he lives near a Japanese bookstore.
The same beasts.
Who haunt you.
When you make those student loan payments.
To that state institution.
You call a university.
The same beasts.
Frankie exorcised in '08.
When he took over The Crew.
Vampire Weekend.
Vampire Weekend.
Vampire Weekend.
Me and my clique.
Leavin' chalk outlines.
Outside of the Pop Up Flea.
Peep those rugged clowns.
They soft.
They shook.
They leaking.
They sleeping.
Forget The Bloods, son.
You got bigger problems.
We bleeding madras up in this motherfucker.

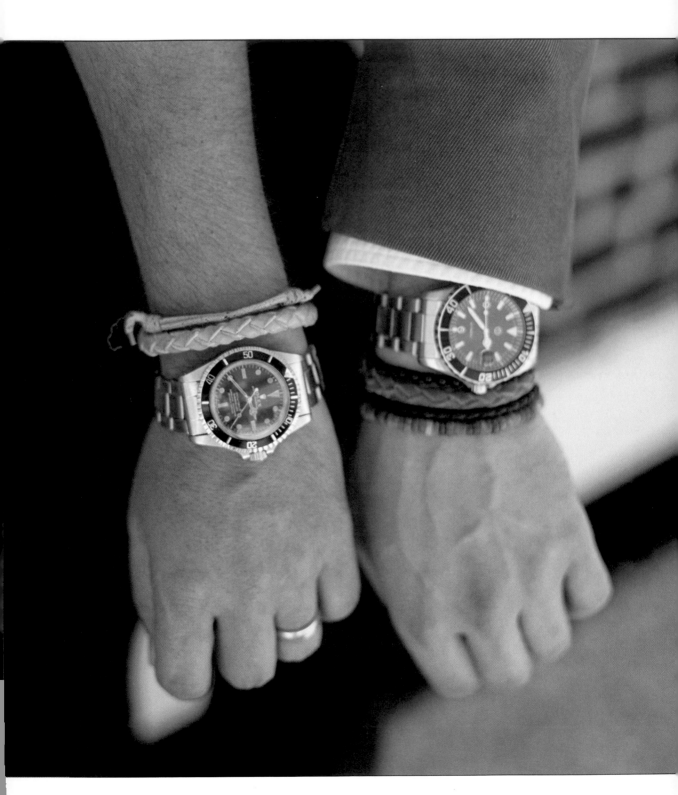

Oh well-o well-o well-o.
Tell me more.
Tell me more.
Err'body back from camp.
Swapping stories.
With mad emphasis.
Not bad, huh?
For some ignorants.
But who told the greatest tale?
Where does the narrative go when we've
 plundered the archives?
Exasperated the canon?
Raped and pillaged the catalog on some
 gully-ass uptown shit?
Tryna sell a product.
Tryna push dust to the fiends.
Tryna pull the H-Tweedy over the eyes
 of the unsuspecting dashmunchers.
Soft shoeing those PR blasts with the
 best of 'em.
Smoke and mirrors.
Up on that vaudeville stage.
And all of a sudden.
Someone yells bullshit.
In the crowded theater we call #menswear.
Where bottom of the map Italian ish gets
 dressed up like Juliet.
And heritage gets tomatoed.
Or is it the other way around?
Go ask Rappo.
Ugh.
Sometimes I just want some crusty-ass old
 head editor to run up on me.
OD at CO-OP.
IRL at Neimans.
Smack me upside my cranial.
With the ill quickness.

Grab my grosgrain placket.
Lift me up off my feet.
Out of this shitty life.
And tell me.
"This is your story."
But until then.
Style Sisyphus.
On that new new.
Couldn't afford Céline.
So I ball hard on my carpus game.
OG charms up on my wristicles.
That shit Bray.
Everyone needs a little support now and again.
RSI from all the RTs.
Steezy Bandz.
Can I trade you?
This one's shaped like Woost God's koi tat.
Enough talk.
Where the fuck is my passion fruit lean?
I'm fighting my way to the pinnacle.
One round at a time.
Fuck your masthead.
I'm in the crow's nest.
Sitting high above the crashing squals.
I'm in a space shuttle.
Floating high above the cosmos.
I'm deep below the Smithsonian.
Chillen in the cavernous underbelly.
Rewriting the history books.
Editing the scrolls.
Polishing the New World Order.
McNasty was a cobbler.
Trep laid wack tweets.
FYMW scrolled the holy post.
Get the hell up out your pleats.

DENIM CARE

AT HOME

For the gentleman who truly appreciates getting mad faded, denim care is mad crucial. To ensure a long and full life for you and your jeans there are a number of fun activities you can do without ever leaving your home. A man is the envy of his friends if he's clearly in a healthy long-term relationship that seems to just keep getting better every time you catch up at brunch.

Getting used to spending time with a new pair of jeans can be uncomfortable at first. We've all been there. The awkward glances down at your legs. The long pauses where neither you nor your jeans say anything. Like elsewhere in life, a great way to break the tension is to sleep together. Wear your jeans in bed and watch as you quickly become inseparable from each other.

After one too many times waking up together on hot summer mornings in twisted sheets, it might be time to freshen up. We all know the dangers of shoving your loved ones inside of a washing machine. Don't wait for your friends to comment on the stench. While you're lathering up in an icy cold shower, drop your Bugle Boys in the freezer for their own brisk refresher. The cold of the icebox will kill all the bacteria that has built up over the past few months and will help delay that awkward conversation of when you're ready for that first soak. If you're both in the mood for more of a deep cleanse, drop your indigo darlings off at the dry cleaners on your way to the spa. Meeting up after you'll both feel great and your stress lines will appropriately be diminished and accented. ∎

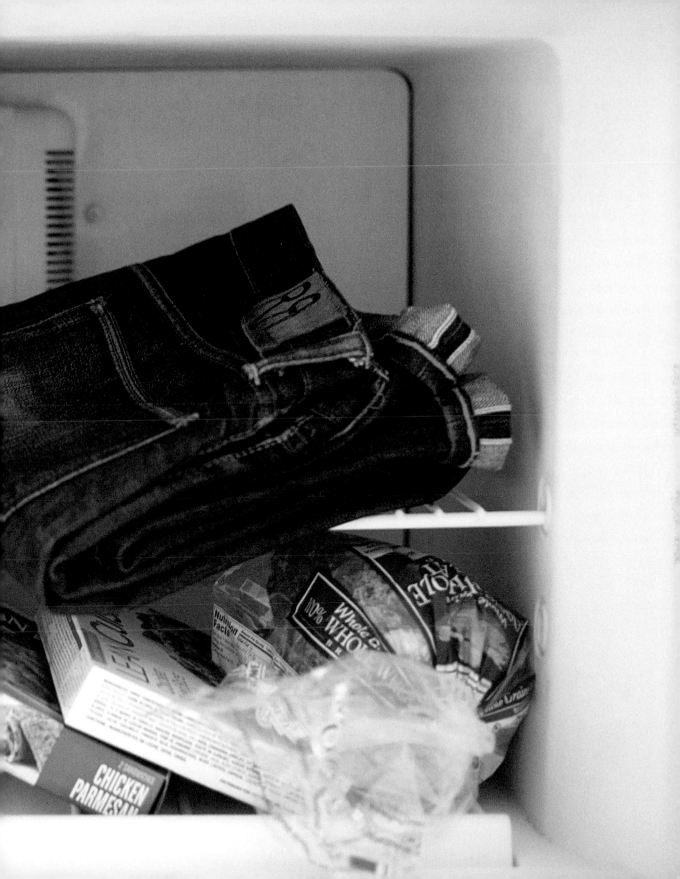

Ocean Soak

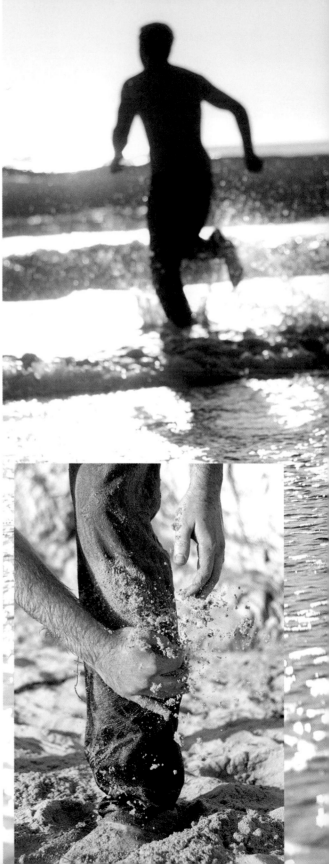

While many great pairings enjoy nights spent together sharing a glass of pino and a capful of Woolite Black soaking in a warm candlelit bath, there are many more adventures to be had.

For those whose love of their jeans knows no bounds, a holiday at the beach is the perfect way to celebrate your one year anniversary. Laugh as you dash out into the waves and splash around to your heart's content. Enjoy basking in the afternoon sun as you playfully rub sand all over each other and then lie on your backs to dry off. When a man is lucky enough to have found the perfect match in their denim, a day at the beach can be truly like no other. You can be assured that these fades are eternal. ■

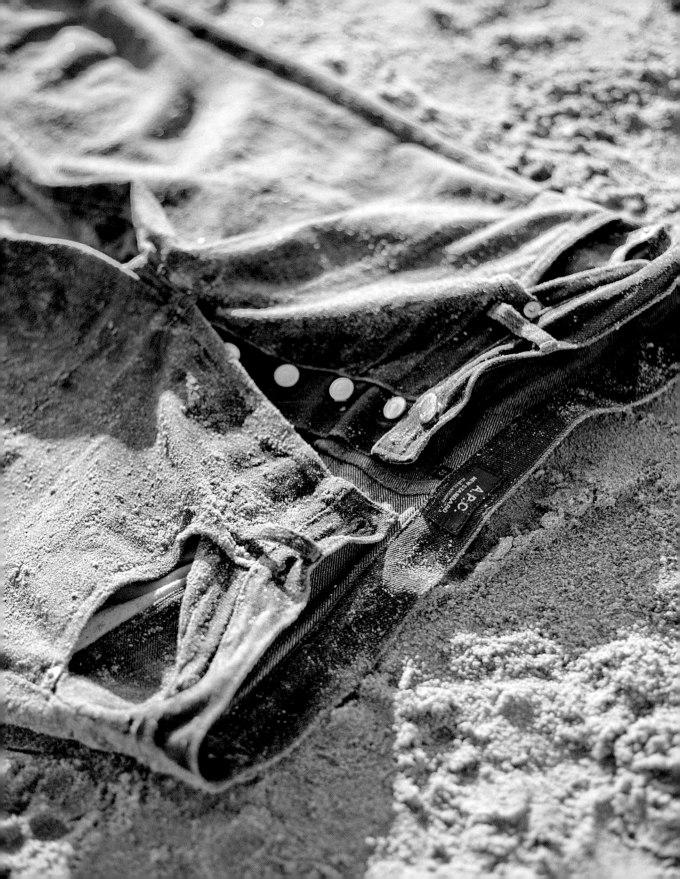

Living life.
Tweed run to tweed run.
An empty passport gathering dust.
But my dreams are full.
A fully realized Anglophile.
Downton on DVR.
Doctor Who On Demand.
I get the culture.
And the culture gets me.
The nuances.
How to pronounce garage.
Did you know.
They spell it "colour"?
At 5am.
Tears slowly ran into my tea.
Kate looked so beautiful.
On the hunt for a brand new flat.
But only turning up "apartments"
 on Craigslist.
Living off the land.
Read about night gardening.
In the Style Section.
Apparently it's already spread to Queens.
Don't want to be late to another party.
Everything tastes better.
When it's grown.
A foot away from my kitchenette.

Neighbors complained about dirt
 on their balconies.
But they haven't smelled the
 freshest mint.
Used with Yorkshire Gold.
For an afternoon of light banter.
I planted these seeds.
I birthed these roots.
I raised these greens.
I am the Queen Mum.
Living nose to tail.
Never wasting.
Eating every last crumpet crumb.
So what if it's only a banana nut muffin.
I bought prepackaged at duane reade.
Used candles from my All Hallow's Eve
 pumpkin.
Melted down to re-wax my Barbour.
Living life.
On the wrong side of the pond.
An empty passport gathering dust.
Shall be no more.
A fully realized Anglophile.
With a ticket booked.
Paid for.
Selling organic tomatoes.
Outside the Brooklyn Flea.

When I first journeyed out here.
I didn't know what to expect.
I didn't have a background.
I didn't have a degree.
I didn't have a pedigree.
Just a passion.
Just a desire.
To understand menswear.
If we can find a link between these men
 and humans.
Maybe we can understand how to dress
 ourselves.
Observed in their natural habitat.
I lived amongst them.
Hiding in sample rack for sixteen straight
 hours.
Standing room at fashion shows.
Bathroom stalls at after-parties.
Under the desk as they cut fabric.
To get that one shot.
Of a male preparing his pocket square.
In hopes of luring a mate.
Adjusting his break.
To let it be known he controls the
 surrounding territory.
I've assimilated into the culture.
Slowly.
Naturally.
One day I shared some food with one
 of the larger ones.
I looked into his eyes.
I could see there was an intelligence there.

He went gently through my hair.
With pomade.
Put a press pass around my neck.
He did pee on me a little bit.
Still unsure if this was an accident.
Or part of some kind of social behavior.
There's still so much to learn.
Others in my field just document the style.
But lest they forget.
Our subjects are practically human.
Some may even dare to say.
They are human.
They have personalities.
They have emotions.
I'm not going to give them numbers.
I've come up with names for them.
That one is Thompson.
Living with them.
Has forever changed me.
To be able to document these rich and
 bizarre creatures.
Is my life's work.
To let the world know how much they mean.
That their habitat is important.
That their customs are not unlike our own.
That they need to be protected.
That they are such beautiful animals.
Maybe we can learn from each other.

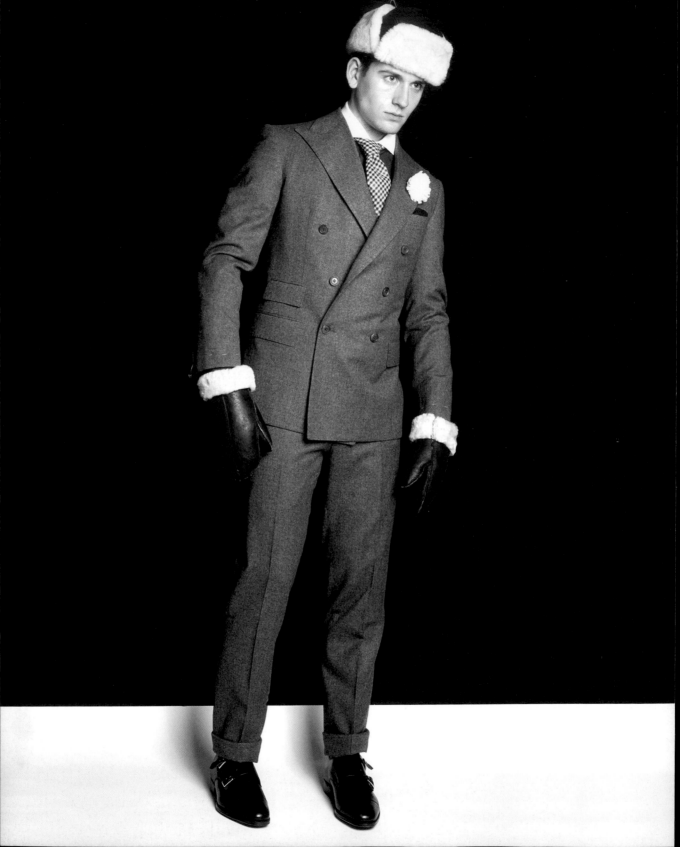

Fuck hibernation.
That shit is mad overrated.
The kid is back on his grizzy.
But don't call it a comeback.
Been had slapping Moncler ass wearing hoes upside their dome piece.
With a goddamn mitten.
It's been a busy fucking winter.
Ya feel me?
Snow globin'.
Globe trottin'.
Trot swaggin'.
Swag jackin'.
F/W 1974.
Détente type shit.
Ushanka stuntin'.
Inspiration board (Cold War remix) feat. MC Ford and Lil' Brezhnev.
Brrrr.
Ad libs slicker than your lesbian haircut.
More twisted than your barber's mustache.
Cleaner than your new brogue booties.
Have you ever sniffed the city's salt?
Leather sole obsessive compulsive disorder.
LSOCD.
Skipping NYFW all together.
Sitting on hella invites.
Natch.
But who wants to kick it with 20-plus broads?
When you've got a cockblock parading as a press junket.
When all the good dickwear has already graced Euro catwalks.
When you're already the heart of the city.
Robbiegella chain.
Only Built 4 Lincoln Center ain't swag.
Itineraries ain't swag.
#fashunz ain't swag.
Nah, son.
I'll roll my trousers.
Double down on four-in-handies.
And sip my Rozay all alone.

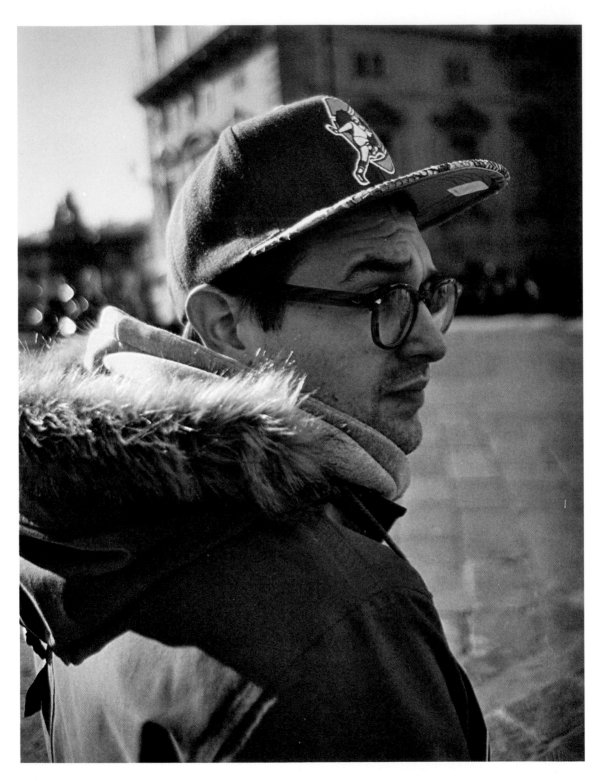

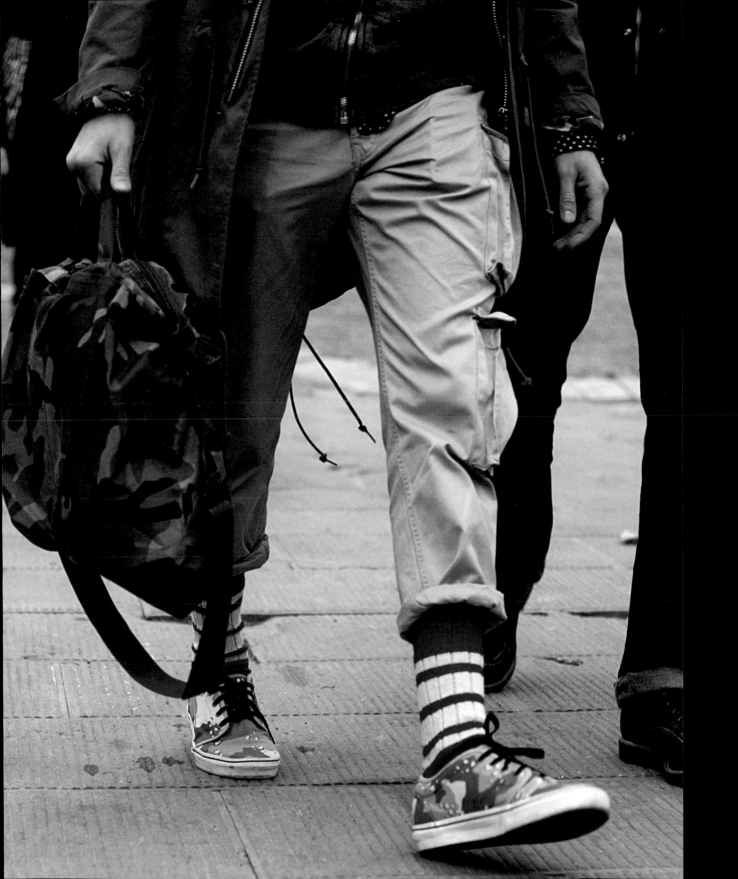

Tell me about your childhood.

What is your earliest memory?

Do you have any recurring dreams?

Perhaps of a time when you were scared?

You suddenly find yourself in the women's section?

You say you have trouble in relationships?

How so?

Are you a buyer or a designer?

Which role do you prefer?

And, what do you think that means?

When you look at my scarf.

How do you feel?

Does it make you want to sleep with Massimo Piombo?

Hmm.

Interesting.

You button your cardigan with your left hand.

Very interesting.

I can see you're worried.

Tell me more about the time when you launched your first collection.

Repressed emotions.

Can lead to much larger problems later on.

What was your relationship like with your tailor growing up?

Did you even have a tailor?

Show me on the mannequin.

Where he measured you.

What does this say about your personality today?

Are you afraid of commitment?

Your closet is strikingly empty.

Much too empty for a man of your age.

And that's our time for this session.

Met with Patient "X" again.

It's too early for an official diagnosis.

But.

I'd wager on aggressive psychosis.

Coupled with possible stage-five OCBD.

Loss of contact with reality.

Caused by early traumatic experiences in a cashmere mill.

Definite PTSD.

Post-tailor sprezz dishevelment is off the charts.

All manifesting into paranoia and bouts of delirium.

His work will never be the same.

The onset symptoms began last season.

The collection was pure insanity.

Will need further sessions to delve deeper.

Still no clues as to why he refuses to wear jeans.

A curious fellow indeed.

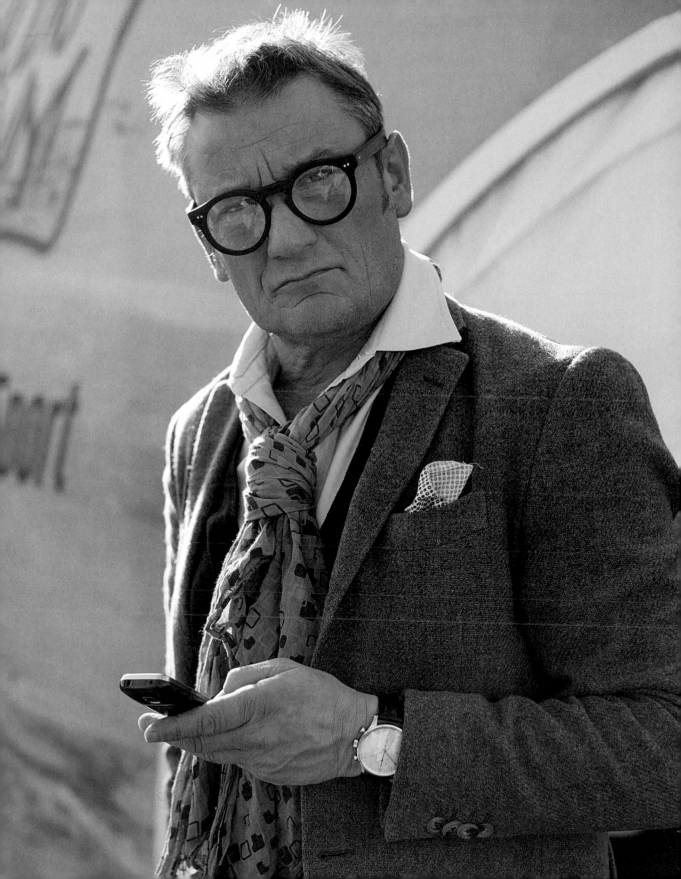

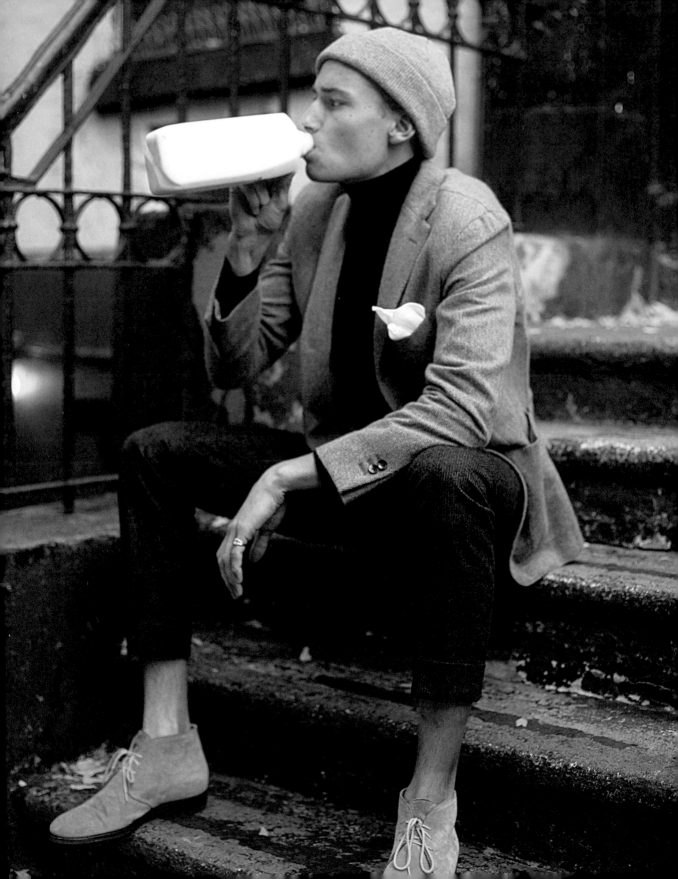

GUIDE TO SHOPS

✂

*These are the ideal spots for those men who understand
the importance of a fucking great retail experience. Once
you've shopped a store where you're offered a free drink,
given big ups on your kit, and been told that the four
things you wanted to cop are all one-of-one and sold out
within the first five minutes of walking in the door,
you'll know you've transcended. Post up, shoot the shit,
and spend some of your hard-earned racks on
some gloriously stocked racks.*

ARROW AND »—→ ARROW

Austin's no-frills menswear destination. Stop by instead of seeing that shitty band at SXSW (Austin, TX).

ASCOT CHANG

Made-to-measure European panache cut by Far East masters (NYC).

BARNEYS NEWYORK

Big box retailer with bigger taste and an even bigger selection (NYC).

BERGDORF GOODMAN

A stone's throw from the extremely upscale Plaza Hotel, this menswear department store gets more expensive with each floor (NYC).

BILLY REID

Eponymous label of all-around good guy Billy Reid, based out of Florence, Alabama. Dapper plantation owners mingle with dudes who didn't die while filming Deadliest Catch *(Florence, AL).*

BLACKBIRD

Seattle hipsters with great taste (Seattle).

Now Italian owned, The Brethren are as continental as they are domestic. Get your OCBDs from the guys who invented them (NYC).

East Coast trad finds a home in the City by the Bay (SF).

C'H'C'M'

Minimalistic retail approach to the clean, utilitarian menswear that will be on your favorite blog six months from now (NYC).

The insanely stylish hub of an insanely hammered Midwest college town (Madison, WI).

A targeted dose of sprezz for those who weren't lucky enough to grow up riding scooters, eating gelato, and smoking two packs a day. Uptown meets Naples at this exclusive boutique (NYC, SF, Palm Beach, Vail).

Brooklyn- and Manhattan-located private label haven with the assorted items to fill your closet. Slim trouser game strong (NYC).

FREEMANS SPORTING CLUB
MADE LOCAL, BUY LOCAL
NEW YORK, NEW YORK

Once simply a barbershop, FSC now makes clothing that updates Americana with a downtown edge. No need to check your mustache at the door (NYC).

Formerly an American Ivy staple, Gant is now a Swedish take on classic American menswear archetypes (NYC).

Run by a couple with deep roots in denim manufacturing and a love of everything indigo. Dress like The Outsiders *in what used to be a gas station (Nashville, TN).*

Stuffy, dusty, classic fit Ivy style done for guys with an actual Ivy League diploma (Cambridge, New Haven, NYC, Washington, DC).

JACK SPADE

Men's clothing made by Kate Spade's husband and David Spade's brother that mirrored his personality—quirky and irreverent. While he is no longer involved, the brand still carries his spirit (NYC).

Eccentric men who have varied tastes should call and set up an appointment beforehand (NYC).

LEFFOT

New York City's feast of shoes (NYC).

LIQUOR STORE

J.Crew pretends they run consignment in the Hamptons (NYC).

L.L.Bean

Bean boots, Norwegian sweaters, and piles and piles of catalogues. One hundred years of dressing white people from Maine (Freeport, ME).

Archive pornography for the Americana set. Shop where your favorite designer buys his inspiration (LA).

The locally made and designed brain trust that houses Engineered Garments, Needles, South2West8, etc. Pegged fatigues, rare Birkenstocks, and ponchos are closer than you think (NYC).

OÐIN
New York

Contemporary menswear for the monochromatic creative with deep pockets (NYC).

OPENING CEREMONY
Est. 2002

Collabos on overdrive. A taste of Tokyo's manic sensibilities. There is nothing too bizarre for the racks at OC (LA, NYC).

RODEN GRAY

A Canadian take on a classic menswear assortment. Northern neighbors with a good eye (Vancouver, BC).

Ralph Lauren's high-end vintage-inspired Americana cosplay. Perfect if you want to dress up as Lifschitz playing dress-up (NYC, Hamptons, LA).

SATURDAYS
SURF NYC

It may not be actually possible to surf in Manhattan, but that doesn't mean you can't look incredibly laid-back and cool while drinking a delicious artisanal coffee in their back courtyard (NYC).

American stockist of the best Japanese jeans assortment. Denimheads lay down their selvedge and pray to both the west and the east locations of their Mecca (SF, NYC).

SID MASHBURN

Often aptly described as the best store in America, Sid is the guy who made double monks cool. For those looking for everything good to better to best, this is where the Southern gentleman meets southern Italy (Atlanta, GA).

SOUTH WILLARD

An oasis of sleek European minimalism. A store so stereotypically too cool for school, it was written into How to Make It in America's *script (LA).*

steven alan

Steven's uniquely classic private label. Twisted plackets for you and all your friends (NYC, LA).

Supreme

Subculture cool that's as much about grip tape as it is about collaborating with Adam Kimmel (NYC, LA).

UNION

Specializes in stocking hard-to-find brands in limited quantities before they are cool. It's where Mos Def shops when he's in LA (LA).

UNIS

Understated menswear basics designed by a lady who's hotter and cooler than your girlfriend (NYC, LA).

A tourist trap of cheap basics with a Japanese fit (NYC).

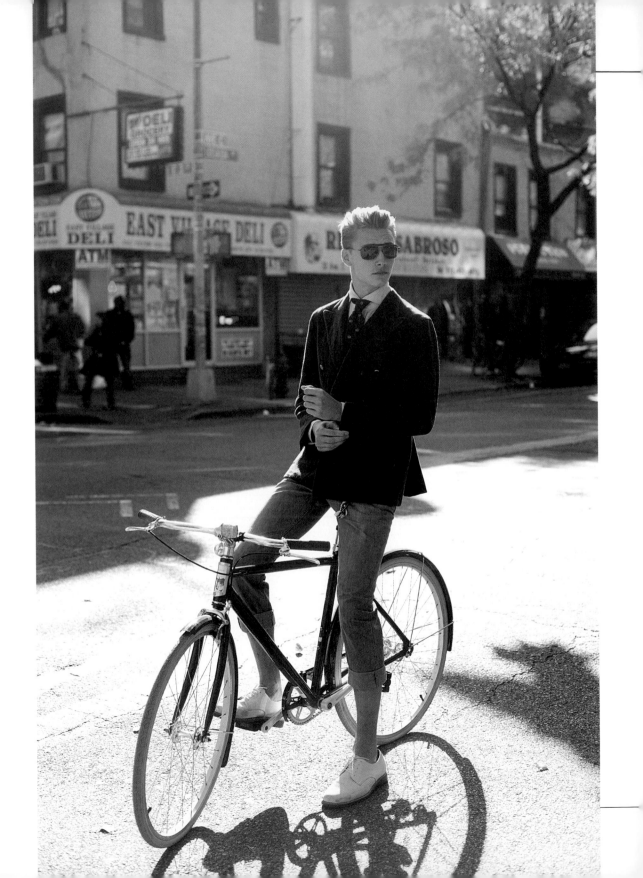

Nov. 18th, 2007.
He shot Thom.
April 12th, 2010.
He shot Simone.
This is the spot.
I'm sure of it.
This is my moment.
Today's the day.
I'm up next.
Finally.
Finna style.
Finna get shot.
Call me Fitty.
Sent a text to Mom.
Finna make moves.
Finna blow.
Finally.

Staked it out.
Did my homework.
Overnight surveillance.
Shift swap.
Black ops.
On black tops.
In black smocks.
With high tops.
Converse x Comme des Garçons.
Play, play?
Never that.
For real, real.
56th hour.
Holding down my pose.
Holding down this stare.
Holding down these sleeves.
He'll be here soon.
I can feel it.

You know how many times I've had
 to check my hair?
In these mirrored lenses?
You know how many times this surgeon
 cuff's been unbuttoned?
Then re-buttoned?
Threads are unraveling.
Boom.
Metaphor.
You know how long it takes to get chafed?
When you free ball in manpris?
Seriously.
Do you know?
I'm flexing so hard right now I might puke.
I might dry heave.
I might piss myself.
Hold up.
Who's that?
Could it be?
That familiar shadow.
That familiar lens.

Those familiar auteur hands.
Coming right towards me.
This is it.
This is it.
This is . . .
Where is he going?
Did he not see me?
He just walked right past me.
What else do you want?
I'm Adonis in the sunshine.
I'm Armstrong on the Moon.
I'm goddamn Abraham atop the mount.
I did this for you.
I do this for you.
I do this all for you.
Fuck it.
57 hours in.

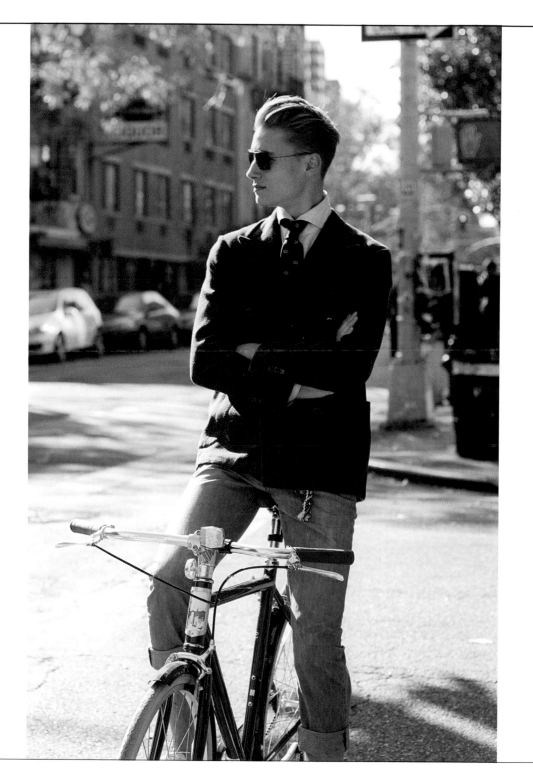

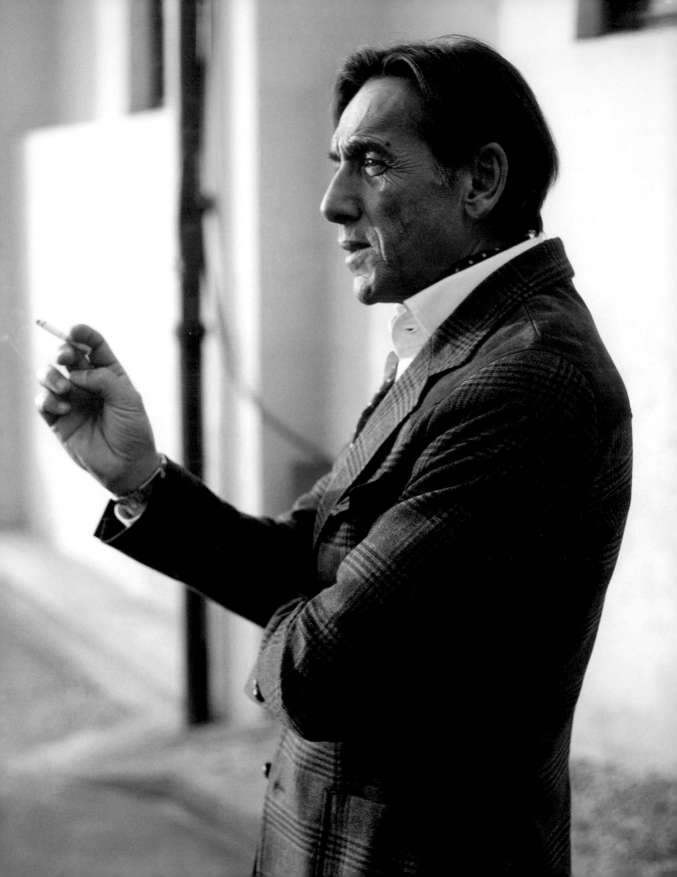

Fill a Serrato.
With some motherfuckin' Gershwin.
Nights.
When it's dark out.
Skylines.
City skyscrapers, but like, all together.
Stars.
Balls of fire, but really far away.
Memories wax strong in this era.
There are no more greats.
The gods and titans have either fallen.
Or left.
And here I stand.
I shook hands with Agnelli.
Back when men understood.
What it meant to be a man.
He had sweaty palms.
It used to be so simple.
There used to be respect.
Men like me?
We don't change.
We don't ever change.
We either stay sharp.
Or get sloppy.
Or settle in suburbia.
They said I paid my debt to society.
On consignment.
Well.
I've come to take it back.
One last job.
One last collection.
Two last lasts.
They say I'm crazy to go up against the big boys.
They say the houses always win.
Design long enough and you never
 change the stakes.

They co-opt your style.
Steal your inspiration.
Unless, when that perfect season comes along.
You bet.
And you bet big.
Maybe I'm nuts.
But at least I've got balls.
I'm gonna need a crew.
A full operation.
We'll need at least a dozen guys.
The right combination of skills.
Knits.
Wovens.
Two pattern cutters and a garment dyer.
A tailor with quick hands.
Anyone know a cordwainer down on his luck?
Toss in a couple of desperate interns.
Not to mention the biggest tannery known
 to man.
One last big play.
The debut.
The bait.
The switch.
The take.
Invitations posted.
Set built.
Chairs laid out.
Models casted.
This tux fits a little differently than
 I remember.
Tried.
But never convicted.
Cue the Gershwin.
And start the motherfuckin' show.

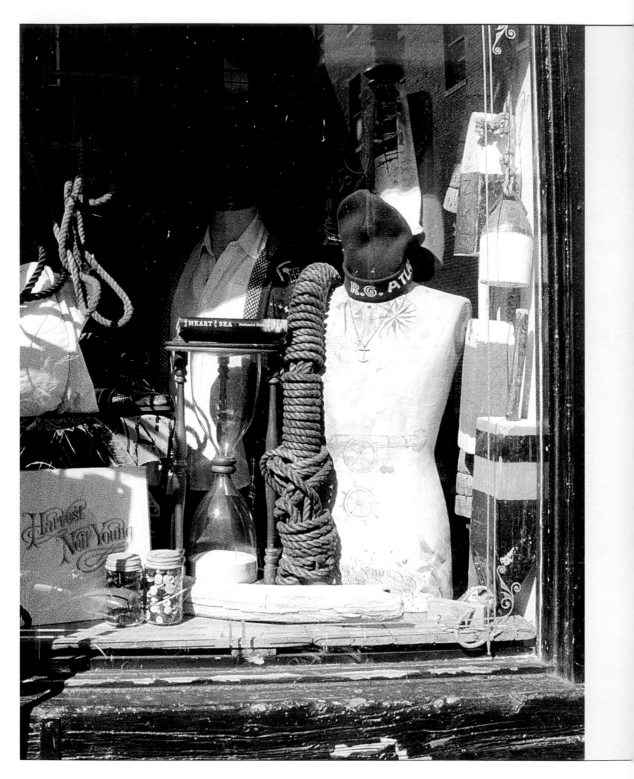

Merchandising

[**mur**-ch*uh*n-dahy-zing]

He'd been on the road for weeks in India. Hopping trains and riding in the stuffy backs of taxis down alleys under the midday sun. Shirt stuck to his back with sweat, he stepped into the shade of a small shop. He had found it. The perfect rug. Handwoven, expertly crafted, he quickly paid for it with the company card and arranged for it to be shipped back to the States. "For your home?" the shopkeep asked. He smiled, shaking his head no. This rug was destined for something much greater. For the next six to eight months it would sit rolled up against the wall among a large pile of clutter in a SoHo pop-up shop. Just one of the many purchases in the life of a merchandiser, and he had to get going if he wanted to catch his flight to Hong Kong that evening.

A single set of clothing hung on a rack does not inspire. A shirt could take thirty-five individual steps to create, but when lying limp on a table in the middle of a shop, it will fail to sell time and time again. Brands spend months designing and crafting their apparel. But creating the desire to own a product requires its own set of challenges, and that is where merchandisers come in. No one will buy a product on its own. It's all about the context in which the product is presented and the story behind it. A cricket bat and book bag placed together with a rumpled Oxford shirt immediately transport the customer to boarding schools and boys getting into one too many pints.

A low chandelier flanked by majestic stag heads gives a little extra weight to that tweed suit and hastens hands to wallets in search of the one card that's still not maxed out. Brands hire merchandisers to scour dusty estate sales, upstate flea markets, and with deep enough pockets, even exotic foreign locales for the accoutrements that will help tell the story of the brand. A well-merchandised store becomes a portal into the world of the brand and displays the clothing in a mixture of signifiers and motifs that turn the mundane into the must-have.

Brands sell stories and lifestyles and the merchandiser is the spinner of tales. A modern master of retail and oft-cited are the stores of Ralph Lauren, who never ceases to amaze with the finest details and no spared expense, whether it be a converted mansion or an entire Colorado ranch. But merchandising can come in many forms. Even brands that are minimal to the extreme and entirely product driven are selling a lifestyle. Thousands of dollars and hours can be spent to find an artisan metalworker to craft the open plan lighting fixtures or to discover the perfect shade of white for the stark interior of your favorite minimalist shop. For those with less time, a quick and dirty merchandising solution is the posting of a "mood board" in a store interior. Used by designers to assemble and focus ideas and a visual "mood" for a collection, this elevated form of collage can often be seen transferred into retail spaces. The juxtaposition of a photo of Sean Connery, a black-and-white shot of an orange, and a scrap of a Japanese kimono can quickly get the creative juices flowing and your customers enthralled with the "vision" of a brand. Merchandisers live for those moments, when brands cease to be physical and become the intangible. Always out of grasp, always at the center of desire. ∎

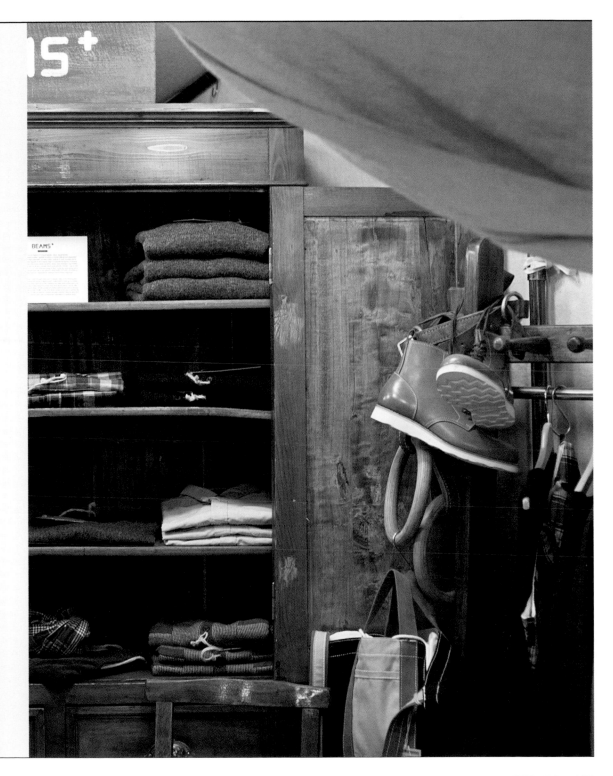

I believe in nothing.
There is no meaning.
There is no purpose.
There are no feelings.
There is no color.
There is no understanding.
We exist in a random series of events.
That we happen to observe.
Clothes are just pieces of fabric.
Hanging off bodies.
Why even wear them?
We could all be dead tomorrow.
Or just keep living forever.
It really doesn't make any difference.
If your suit is Super 140 or not.
Just leave it to the professionals.
There is no point.
Just stop.
Or continue.
Or cop some dope Rimowa.
Or cover yourself in mud.
It doesn't even matter.

You weren't destined to be stocked.
God didn't bless you with the gift of
 pattern making.
You are a mass of flesh.
Being animated by pulses of electricity
 in your brain.
Taking up space on a rock in the
 middle of nothing.
We are all stuck in a cycle.
Of meaninglessness.
Just don't bother me.
Don't sell me the latest season.
Don't try to sell me the latest brand.
CAUSE I ALREADY GOT ALL
 THAT FLY RICKY SHIT STOCKED
 MOTHERFUCKA!
TEAM OWENS, WE KILLING IT
 THIS YEAR!
WE DON'T GIVE A FUCK!
BOW BOW BOW!

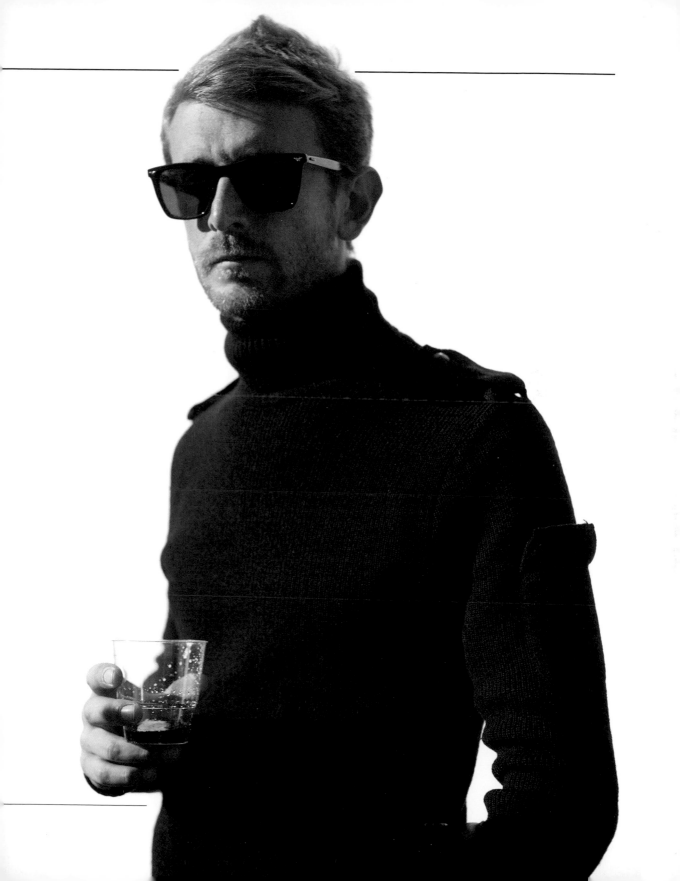

Dirty bucks in the alley this morning.
Blood from blisters on insoles.
The city is afraid of me.
I've seen its closet.
Filthy animal print.
So much rotting fabric.
In afternoon wind.
Downtown needs protecting.
Though from the looks of dirty hipsters.
That scream fair trade coffee.
Through Made in China keffiyeh.
Wouldn't know it.
They don't deserve me.
Man stands on precipice and jumps.
Not much complaining from me.
Watch him go splat.
Pavement stains.
Leaves patina.
At least something remembers.
What happened to wearing clothes
 'til worn out?
New, always new.
Like nude bodies writhing in sunshine.
Told we can't be happy.
Without shiny new parkas.
Now the whole industry stands
 on the brink.
Staring down into bloody Hell.

All those bloggers and editors and
 publicists.
And all of a sudden nobody can think
 of anything to say.
I'm the only one left with any mercy.
People had a choice.
They choose to live in this bile-filled
 land of re-appropriations.
Cold wind coming through.
Pop collar.
Never compromise.
Not even in the face of all this bullshit.
That's always been the difference.
Between you and me.
The accumulated filth of all their
 purchases and flips.
Will foam up around their waists.
And the brand whores and the buyers
 will look up and shout.
"Save us!"
And I'll look down.
And whisper "No."
Clothing is random.
It has no pattern save what we imagine
 after staring at it for too long.
No meaning save what we choose
 to impose.

This rudderless world is not shaped
 by vague editorial photo shoots.
It is not God who kills style.
Not fate that butchers it or destiny that
 feeds it to the dogs.
It's us.
Only us.
Heard a joke once:
Man goes to stylist.
Says his wardrobe sucks.
Says his clothes seem outdated
 and wack.
Says he feels all alone in a threatening
 season.
Where what trends lie ahead are vague
 and uncertain.
Stylist says, "Treatment is simple."
"The great designer Tommy Hilfiger
 opened a pop-up shop on Bleecker."
"That should set you up."
Man bursts into tears.
Says "But . . . I am Hilfiger."
Good joke.
Everybody laugh.
Roll on camera shutter.
Curtains.
Fade to black.

Nature vs. nurture?
It's tough to say.
When your DNA is this fucking crispy.
And as a young'n you kicked it in Pari.
Your kid probably geeks out over trivial shit.
Like butterflies.
Or clouds.
Or glitter.
My kid gets wide eyed.
When we discuss the merits of white jeans
 in winter.
Monochromatic palettes.
And well worn DBs in exclusive colorways.
We took him out of school two years ago.
So he could blog full time.
His diffusion line for Heelys hits Target
 next month.
Apparently it's Jil inspired.
I've only seen the sketches.
You probably heard him at SXSW.
Moderating a panel with Lil Gevi.
And the son of that dude who created *Mad Men*.
Talking about the merits of social media.
And musing on what it means.
To inspire a generation of designers.
Who made names for themselves.
Before any of these Rugrats were even born.
They say rents live vicariously through their seed.
I'd have to agree.
I tweet vicariously through him.
Because he has more followers than me.
While you're in a Town & Country.
Stuck in traffic.

Taking your worthless brat to soccer practice. In Brunello's booth.
I'm speeding in a Hummer limo. At Pitti Uomo.
With my kin. My mealticket.
And Uncle Karl. My only son.
Popping bottles. The truth.
Making our way to the front row. The future.
This really shouldn't come as a shock. My legacy.
I mean. Steezus Christ.
He was conceived. My only son.

I had a dream.

I was Italian.

I was the stallion of steez.

I was the consigliere of crispyness.

I matched my Ferraris to my Stubbs.

I matched my speedboats to my ascots.

My women were bespoke, just like my suits.

Double breasted.

Always.

I took hard drugs on holidays.

And holidayed on hard drugs.

Seersucker in the coldest of winters.

Wool flannel in the most sweltering of summers.

In all my sartorial splendor I ravaged the world.

And broke every single rule I saw fit.

Shopping sprees with Willow Smith in Milan.

Racing dirtbikes through the Tuileries Garden with Shia LaBeouf.

I made him cry.

I was your favorite blogger's favorite blogger's muse.

Sat front row at Fashion Week, but I was on my iPhone the entire time.

And they still invited me back.

Year after year.

Year after year.

Year.

After.

Year.

I had a dream.

I was Italian.

I was the stallion of steez.

I was the consigliere of crispyness.

"What the fuck's a blog?"

"HAHAHAHA."

'BOUT THAT LIFE

If the clothes make the man, the accoutrements make the lifestyle. Sun filtering through your Persols, you pick up your G&T at brunch. You're surrounded by all the homies, and your full-time squeeze is at your side. Some dude across the street falls into a puddle and ruins his cheap-ass off-the-rack suit. The table erupts in condescending laughter. You are fucking gods and the rest of the world is your playground. We out here living.

DSLR CAMERA

If steez happens in the street, but no one is there to snap shutter, did it actually happen? No need to worry about any of that existential bullshit if you've got your own camera. Serious blog heads know that a simple point and shoot won't do, however. That joint makes you look amateurish and poor. Instead you want to step up to some big boy machinery. The DSLR, which stands for some scientific nonsense no one cares about, should be your go-to for capturing everything swagged out. Accessorize with a dope strap and hit the streets to obtain all the proof you need that you're cooler than everyone else.

VINTAGE SPORTS CAR

A great whip is not so much crucial as it is encouraged. Even if you live in a city with amazing public transportation (unlikely, of course, because public transportation is wack by definition), a vintage sports car can put you over the top. In addition to getting you from point A to the nearest pop-up shop, a car can serve as a mobile closet. With access to multiple wardrobe changes throughout the day, you never have to worry again about being underdressed for a cocktail party or that street rules pickup game of volleyball against the douches that work at American Eagle. There may be no better feeling than cruising with the top down as your lapels flutter in the wind—you know, the kind of thing that gives Lapo Elkann a semi. Just think, would you rather holler at hoes from the driver's seat or the bus stop?

COFFEE SPOT

A successful day of shopping or blogging always begins with a hearty breakfast of coffee to get you straight buzzed for the proceedings. To separate yourself from pathetic tourists and people who don't appreciate the finer things in life, you want to lock down a place that makes coffee for a daily visit. Your order becomes a simple nod of the head leaving you to stay focused on tweeting something irreverently clever followed by a quick industry insight as multiple women munching on croissants daydream longingly in your direction. You will begin referring to it as your "joint" or "spot" and lambasting any coffee not brewed within its confines. This will give you the perfect fodder to dismiss herbs and their stupid fucking recommendations.

BLING

Some dudes are not comfortable with flaunting their style with accessories. These dudes are lame and content with existing on a previous level. Those of us who exist on the plane of next levelry know how important "bling" is. In this case, "bling" is really a blanket term. Your slick stainless steel Rolex Sub is bling. Your Cartier cufflinks are bling. Shit, the friendship bracelet your blogger pen pal made you is bling. Moral of the story: don't be afraid to accessorize as if the number of items directly corresponds to the size of your penis.

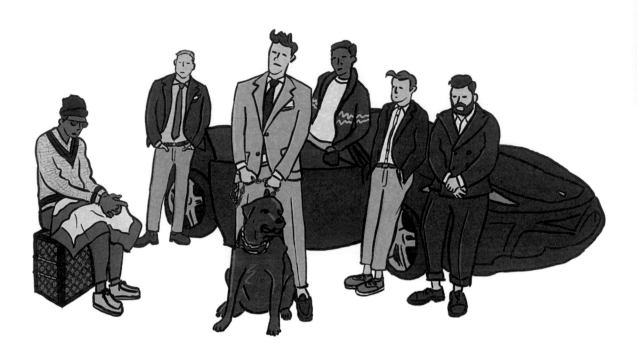

A CREW

History has given us a great share of cliques and crews. From the Pilgrims to the Antwerp Six to Dipset, those who have rolled deep have found success. Flying solo can often brand you as unapproachable or weird or herbish in your tendencies. Surrounding yourself with others automatically gives off the impression of likeability and friendliness. From a personal perspective, think about how much better it is to do fun shit with people who also like to do fun shit. Dudes who are down to swag out at a moment's notice. Now keep in mind that while simply being a crew member is enjoyable, it is not preferable to actually leading the clique.

THE LAB

The lab is where it all goes down. What's "it," you ask? Well, "it" is your work, your grind, your hustle. Maybe your lab is that heavy-ass metal desk you lugged home from the flea market. Maybe your lab is your wealthy walk-in closet where all the hangers have molded shoulders. Maybe it's some minimalistic annex that features a maximum of two items purchased at IKEA. Regardless, the lab is where you cook up your greatness. Where you prepare what the world's been waiting for. Creating the shit that is impossible to be slept on. The world is your princess, and the lab is where you put mad peas under her mattress.

VACATION HOME

The game is stressful, no one is going to deny that. Sometimes you need a getaway to get all introspective and whatnot. The vacation home (or homes), wherever it may be, should be as palatial as your means can afford. From the Florentine palazzo to the Aspen cabin, the vacation home is also the focal point of your retail therapy nerve center. Remember, you're not running away from your problems when your name is on the deed.

DOWN FEMALE

Throughout time, great men have typically had great women by their sides. This is a no-brainer. No matter what your status, your down female is there to support and help you achieve your goals. She's strong willed, and you're gonna bump heads, but she's been on board since the jump. She kills it in a formal dress almost as much as you in your custom tux and lets you know when you've been slipping on your tweet game. When you can't decide between suede or cordovan loafers and she tells you "cop both," you know you've found a keeper. Arm candy for hitting up collection presentations or a shoulder to cry on when your bank account is tapped out the day of that sample sale, down females are a must. (If you don't mess with chicks, flip the gender listed above and you're good to go.)

FINE-ASS FURNISHINGS

Accoutrements are just as important to your wardrobe as they are to your life. Whether you've got an original Warhol or a framed Supreme ad you ripped out of a magazine, fine-ass furnishings help you mold your lifestyle as if you were Zeus making people out of clay or some shit. Sick furniture should not be overlooked. You want to be the guy bragging about his Eames chair, not the guy sitting across from the guy sitting in his Eames chair bragging about his Eames chair.

A COLLECTION

Anyone who is truly 'bout that life knows a thing or two about discipline. The perfect way to flex this muscle is with a collection. Whether obscure and pretentious (artifacts smuggled out of Egypt) or just flat out baller (military-grade helicopters), the thrill and appeal of collecting are unmatched. From the hunt to the discovery to the acquisition to the addition, the process is childish in just the way that only an elegant gentleman can appreciate.

We didn't want it.
The rumble was upon us.
The street skeezers assembled quickly.
Word is that one of the prepset was seen
 shopping at Milord.
The nerve.
On our turf.
Prancing around in a bow tie.
In broad fucking daylight.
Soo woo!
Battle cries echo across so much concrete.
Blood has been running hot ever since
 last week.
One of our crew got CC'd on a PR blast
 from Vineyard Vines.
The fuck.
He unsubscribed just in time.
Homey has been laid up in bed ever since.
Traumatized.
By what he saw.
Clearly some preps stepped a little too far
 outside the boat house.
We left a cut up Bean boot in the middle
 of the Piazza.
To send a message.
Molotov cocktails cocked back.
Aimed at the country club.
We don't care who your father is.

We're rolling deep.
With a score to settle.
Stopped by the safehouse.
Armor on.
Pants rolled.
Shirt tucked.
Buckles buckled.
Mirrors checked.
Double checked.
Instagrammed.
We've read your comments.
Can't hide behind anonymous anymore.
We've googled the IP addresses.
And we're pissed.
When you fuck with one.
You fuck with all.
Molded shoulders and shoe trees.
Break jaws.
Better pre-order a patchwork cast.
Holding snitches down.
Ripping school crests.
Now you're broken.
Don't bother getting up.
Complain about my cargos.
All you want.
But these joints are functional.
Where do you think I'm about to put
 your soul?

Woah, woah, woah.
Hold up, son.
You go to a public university?
The fuck is that?
Seriously.
What does that even mean?
Is that one of those places with tuition cheaper than my high school?
Is that one of those places founded after my family already made their fortune?
Is that one of those places that makes you wear socks to class?
Is that one of those places that doesn't have any pics in the Life Archives?
If it doesn't have a school boy at JP,
It doesn't count.
Scarves or it didn't happen.
Is your roommate some fucking townie?
Who wears sweatpants to parties?
And carries ID on lanyard?
And rocks Adidos slip-ons in public?
What's his nickname?
Fucking J-Bone?
Dining hall mealplan?
You don't eat at a club?

Since when does wine come in boxes?
I know a couple drinking games.
I'm really good at this one where you hide
 a dead hooker.
What presidents lived in your dorm room?
They didn't give you the list?
Not even a VP, seriously?
Bouncer confiscated your fake?
Did you just buy the bar?
And fire him?
Work study?
Is that when the help writes your papers?
Studying abroad in Australia?
Really?
I was just there for New Year's Eve.
Shit, gotta make a quick Plan B run.
Can't dilute the bloodline.
Not if I want to sniff that trust when I'm 25.
I wear cream Wallows to the weight room.
Squash in 2-inch cuffs.
And talk to bitches about my full-ride blogarship.
But seriously.
A public university?
The fuck is that?

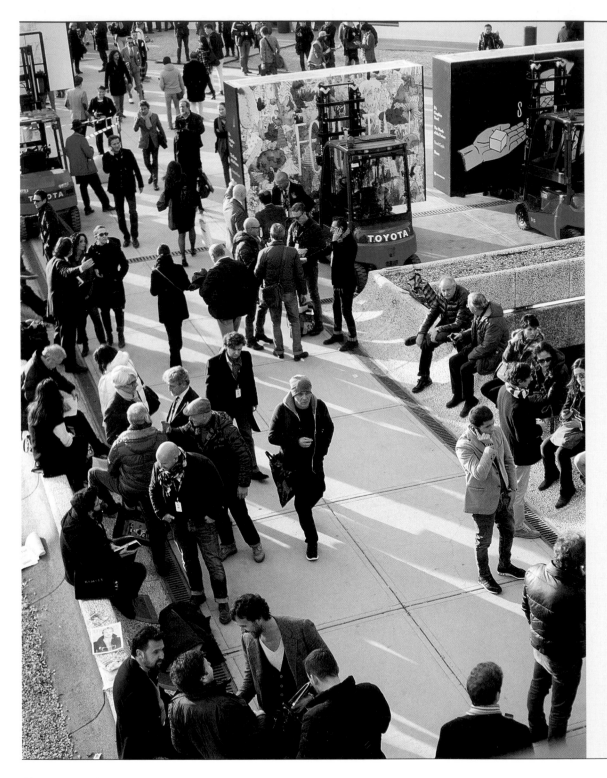

Trade Shows

[treyd-shohz]

To the outside observer or the casual enthusiast, fashion shows are typically looked at as the showcases in which new clothing is presented for the first time. While this may be true for a certain segment of the fashion industry, this segment is, in fact, actually quite small. On the whole, the trade show is where the majority of brands and designers, whether big or small, great or shitty, show their wares for the first time.

The fashion trade show is more or less laid out exactly like that of a trade show for any industry. Similar to a convention, the trade show is typically presented over a large area of space, with participants exhibiting out of booths. These booths can vary in both size and complexity. Some trade shows encourage vendors, brands, and designers in this case, to be creative with their booth build-outs. However, other trade shows encourage a much more uniform, stripped-down approach and thus are much more boring. Regardless, it is in those booths that the clothes themselves are put on display and where, in a perfect world, business transactions occur.

In the fashion industry, trade shows happen biannually during the respective season's Market Weeks. Market Weeks happen sometime during or loosely around Fashion Weeks. This enables editors and buyers to see a new season's worth of clothing within a predetermined window. For example, a buyer may cruise to a trade show to examine new A/W 2013 from specific

brands in New York, and two weeks later see the A/W 2013 collections on the runways of Paris Fashion Week.

Trade shows happen all over the world, but usually can be found in major fashion cities—New York, Paris, London, Berlin, etc. Two exceptions to this rule are Las Vegas and Florence, cities that to the industry outsider may not initially scream "fashion," but have, nonetheless, somehow become crucial stops on the trade show circuit. Florence's Pitti Immagine (specifically Pitti Uomo) is, in fact, the widely accepted leader when it comes to style and taste. It is the only trade show to feature its own street-style canon.

In recent years, trade shows have evolved into complex events that now focus on so much more that just the actual clothing. Once people created the fallacy that having a blog made you a member of the press, the trade show glass ceiling was broken. Thanks to this much lower barrier of entry, trade shows are now open playing fields to the likes of bloggers, photographers, students, enthusiasts, fanboys, no-talent idiots, etc. While new wares are still for sale and business is still the number one priority, trade shows are now a hotbed for fashion networking and independent press.

But don't let the congregation of drunk mustachioed bloggers next to the DJ booth confuse you; the trade show is still an integral part of the menswear business machine. These are not simpleton get-togethers despite the leggy greeters, and they are not retail spots for "copping" the latest "grails" six months early. Proper steps still need to be taken in order to rub elbows with the industry's best and brightest (though a business card does go a long way). "One does not simply walk into Mordor," as the saying goes. Remember, introduce yourself politely, tell everyone they're "best in show," and do not, under any circumstances, post pictures of wholesale prices. ∎

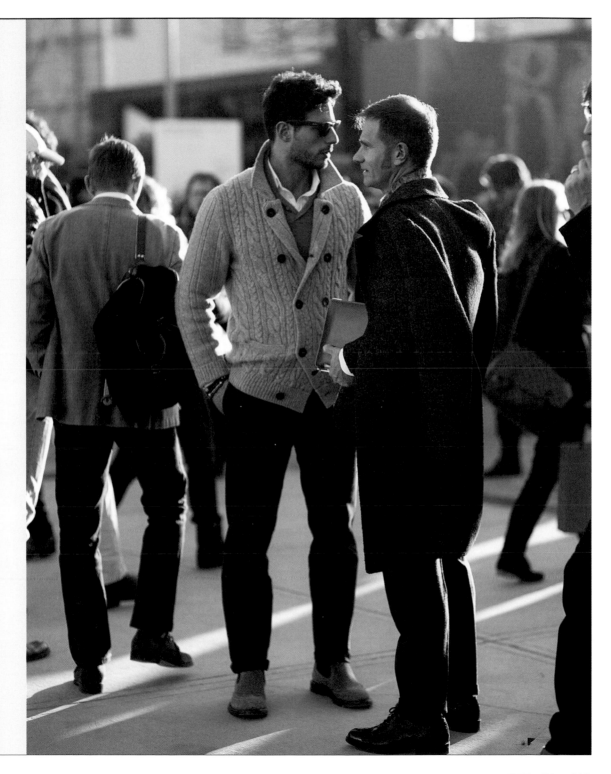

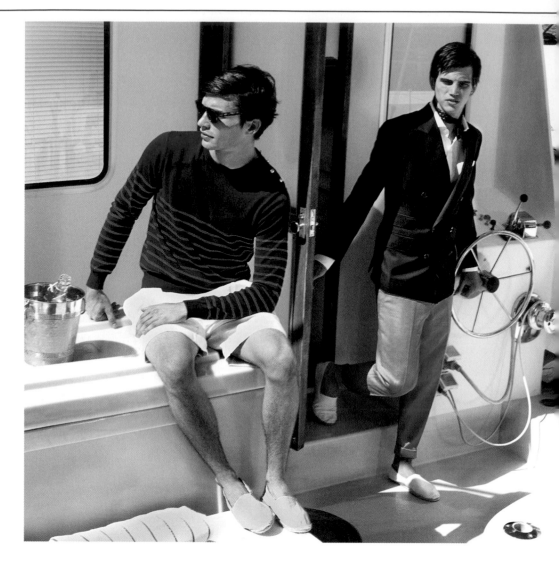

Me and my bros.

Around the blogosphere in 80 days.

In the sartorial dick-measuring contest we call life I'm undefeated.

As long as I've got this yacht the hipsters can never win.

Because they are poor and shop on eBay.

You probably think I'm going fishing with a cooler full of Heinies.

Channeling DJ Paulie Newman on some *Life* magazine archive-type shit.

Think again.

We're not doing anything outside of lampin' in espys, macking this
 fine-ass broad, and creasing our chinos.
It took me 15 minutes to get this bandanna right.
You think I'm gonna fuck that shit up by doing any manual labor
 disguised as a hobby?
My only hobby is looking fresh.
I repeat, my only hobby is looking fresh to death.
I repeat, my only hobby is looking fresh to death on my fucking yacht.

The man with no face.
Behind the scenes.
Behind the lens.
Behind the stall door in the men's room.
Quietly crying.
When will it be my turn?
Who will remember my visage?
Who will consecrate my image?
Who will document my form?
On their preview screens.
I take it all in.
I drink up the tableau.
I flow freely through the spectacle.
I define my existence.
Through these panes of glass.
Concave.
Convex.
Condé Nast.
On all my invoices.
I make icons.
Plucked from thousands.
I find a chosen few.
Before they understand.
Before you comprehend.
I find them.
I capture them.
I make them sing.
I define who defines a generation.
Imitated.
Copied.
Pasted.
On bedroom walls.
Mostly desktops.

Where's my spread?
I was at these shows.
I sat front row.
Rubbed suede elbow patches.
With the elite.
The elite that I defined.
Always on the bench.
Never in the game.
Glimpses of my hands caught through gallant strides.
A face peeking out from behind an overcoat.
You lusted after last season.
As it billows past.
Out of focus.
Once again, I am a ghost.
Milan.
Paris.
Manhattan.
They stop to kiss my cheeks.
They flaunt their collarbones.
But if I showed up to Sunday brunch.
Empty-handed.
Would they embrace me still?
Would they bat their eyes.
Would I find my place card?
Such is my burden.
The great truth tellers get their turn at the table.
But never to dine.
Always to weave.
For the kings and queens.
We spin those yarns.
We highlight their greatness.
The greatness.
That only a photo in the soft light on a
 cobblestone street.
Can capture.

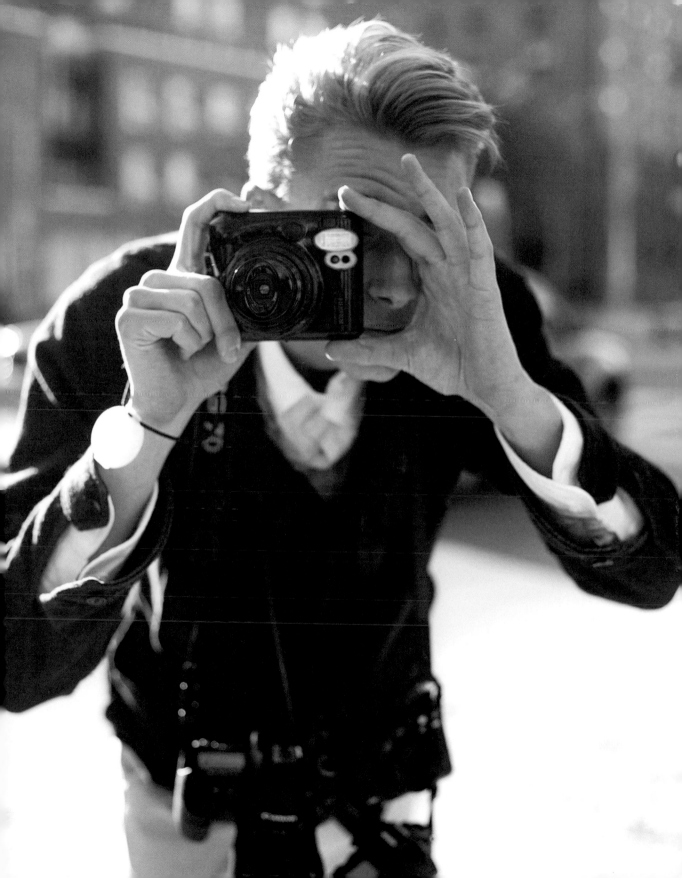

No rest for the steezy.

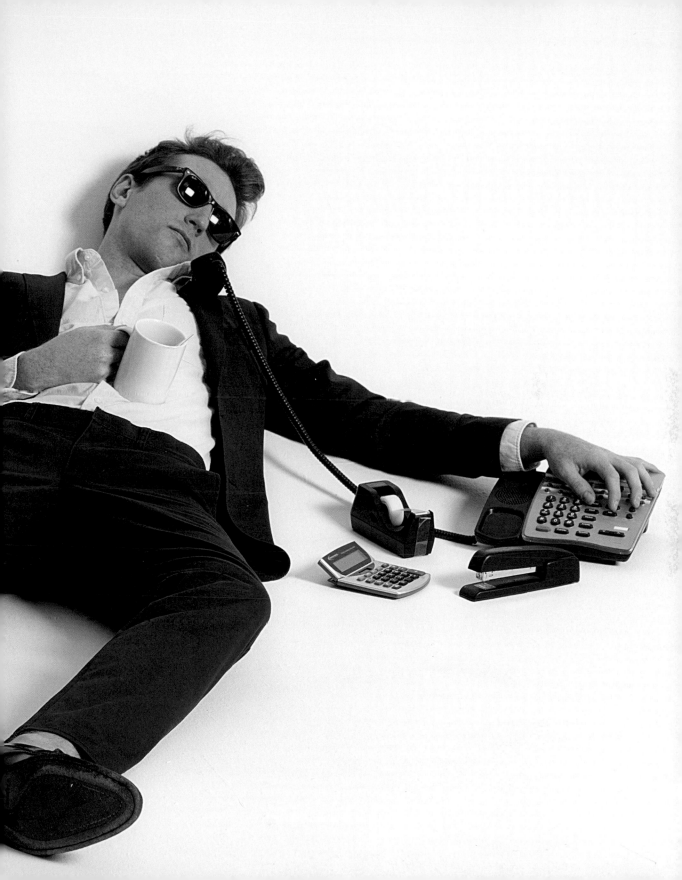

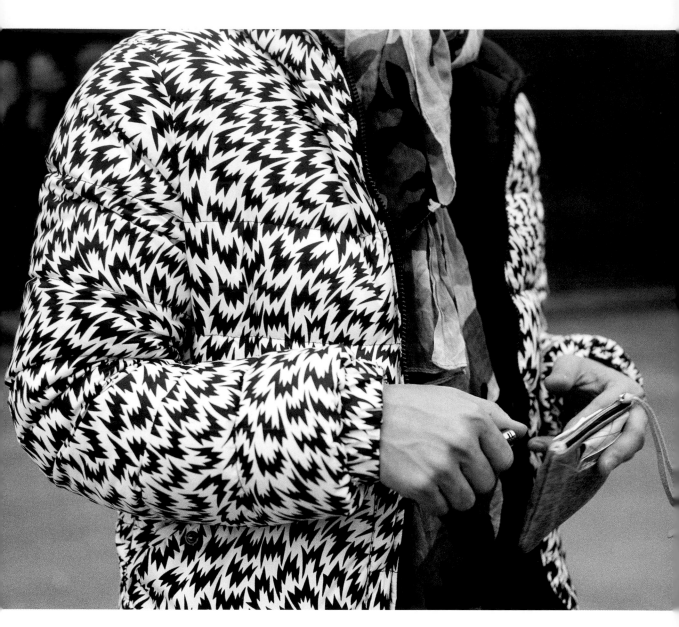

I am haunches and legs.
Pounding the concrete savanna.

STYLE GLOSSARY

— A —

aesthetic [es-**thet**-ik] *adj.* A buzzword often used as a blanket term to denote the feel or style of the garment/collection/designer/etc. in question.

Aldies [**ahl**-deez] *n.* Alden shoes.

archive [**ahr**-kahyv] *n.* The history that makes a brand great. Can be a physical collection of past designs and/or simply records detailing products from times past.

artisanal [**ahr**-tiz-*zuh*'n-al] *adj.* Handmade by highly skilled craftsmen. Typically a sign of luxury. Often used as a justification of price point.

automatic-reblog [aw-t*uh*-**mat**-ik-**re**-blog] *n.* Content so incredible that its sharing between bloggers and blog readers cannot be stopped.

A/W [**aw**-t*uh*'m-**win**-tcr] *n.* Autumn/Winter, a season. May also be written as F/W or Fall/Winter.

— B —

based [beys-t] *adj.* A term often associated with the free-form rapping styles of Lil' B. Adopted to denote something that is incomprehensible in its inherent awesomeness.

bespoke [bih-**spohk**] *adj.* Handmade specifically for you. Often used to describe a custom suit or to signify wealth.

bleed [bleed] *v.* Running dye of a particular fabric. Typically seen with authentic Indian madras and raw indigo denim.

blogger [blog-er] *n.* A person who writes about things on the internet, often in a casual or conversational manner.

blue hands [bloo-handz] *n.* Refers to the blue dye that rubs off onto the hands of a raw denim wearer.

break [breyk] *n.* How long your trousers are.

brick and mortar [brik-*uh*'nd-**mawr**-ter] *n.* A physical retail space. Often considered superior to a digital retail space in the eyes of the industry.

break (*n.*)

brim city [brim-**sit**-ee] **n.** Brimfield. One of the meccas of vintage flea market shopping in the USA. Located in Massachusetts.

b-roll [bee-rohl] **n.** Unused photographs from a photoshoot/lookbook/editorial/etc. Often "behind the scenes" in nature.

B Squared [bee-skwair-d] **n.** Brooks Brothers.

— C —

CFDA [see-ef-dee-ey] **n.** Council of Fashion Designers of America awards handed out yearly. The Oscars of the fashion industry.

collabo [k*uh*-lab-oh] **n.** A collaboration.

cop [kop] **v.** To buy.

collection [k*uh*-lek-*shuh*'n] **n.** The body of a designer's or a brand's work for an entire season.

crispy [**kris**-pee] **adj.** Similar in nature to "fresh" or "clean." A positive signifier when used as a descriptor. "That new shirt is so crispy, brah."

crotch blowout [kroch-**bloh**-out] **n.** When an extremely worn pair of pants, usually jeans, wears in the crotchal area and the seams rip, creating a hole.

curate [ky*oo*'r-eyt] **v.** The art of selecting specific things as applied to an overall vision. Often used by unimportant people with no skills to make their work seem important and skillful.

cutaway [**kuht**-*uh*-wey] **n.** A collar featuring an extreme spread.

CFDA (*n.*)

— D —

dad jeans [dad-'jeenz] **n.** Heavily stonewashed jeans as seen on President Obama and suburban dads all over the world. Formerly a style no-no, dad jeans have seen a recent resurgence thanks to their popularity amongst stylish European men.

Dainite [**deyn**-nahytz] **n.** A brand of high-end rubber soles.

darts [dahrtz] **n.** Truths or facts.

dashmuncher [dash-muhnch-er] **n.** Tumblr follower.

dead stock [ded-stok] **adj.** A never used item that is no longer in production. "These dead stock Levi's from the '50s cost me an arm and a leg."

DIY [dee-ahy-whay] **adj.** Do it yourself.

DM [dee-emz] **n.** Direct message sent on a social media platform.

dressed by the internet [drest-bahy-*th'uh*-**in**-ter-net] *adj.* The ultimate insult. Implies that one's personal style is 100 percent culled from various websites and web personalities.

drop-crotch [drop-kroch] *n.* A style of pants in which the crotch is lowered. Gives the effect of having taken a huge shit in your pants.

DSLR [dee-es-el-ahr] *n.* A digital single-lens reflex camera. Used by professional photographers and photographers posing as professionals.

dub monks [duhb-muhngkz] *n.* Double monk strap shoes.

— E —

editor [**ed**-i-ter] *n.* The pinnacle of dream jobs. A high-ranking position within a publication that determines the focus and direction of said publication.

editorial [ed-i-**tawr**-ee-*uh'*l] *n.* A photography spread based around a certain theme or concept.

e-tail |ee-teyl| *n.* Online retail.

essentials [*uh*-**sen**-*shuh'*lz] *n.* Necessary items of clothing that one must have in one's wardrobe and that are not up for discussion.

— F —

factory visit [**fak**-*tuh*-ree-**viz**-it] *n.* The ultimate in heritage blogging experience in which the place where an item is made and the people behind the manufacturing are observed.

fit [fit] *n.* The totality of your outfit.

fitting [**fit**-ing] *n.* The beginning stages of the made-to-measure or bespoke process in which personal measurements are taken and samples tried on.

flex [fleks] *v.* To show off, but really a catchall phrase that can be used for anything in any situation.

flossin' [flawsin] *v.* Showing off.

FNO [ef-en-oh] *n.* Fashion's Night Out. The ultimate amateur hour in fashion, especially in NYC.

followers [fol-oh-erz] *n.* Your social media reach is determined by those who "follow" you on various platforms. Importance is gauged by how many "followers" you have.

form [fawrm] *n.* A mannequin that consists of only a torso. The perfect way to display the top half of an outfit.

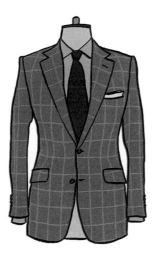

form (*n.*)

forums [**fohr**-*uh*'mz] *n.* Online communities.

four-in-hand [fohr-in-hand] *n.* The only tie knot you need to know how to tie.

front row [fruhnt-roh] *n.* The upper echelon of fashion show/runway real estate. The most important people sit up front, naturally.

fucks wit [fuhks-wit] *adj.* To enjoy. "I fucks wit that new Ralph Lauren collection."

f-word [ef-wurd] *n.* Fashion. Often avoided in the online menswear community.

— G —

____ game stressful [geym-**stres**-f*uh*l] *adj.* A lament. "Ten runways in two days. Fashion game stressful."

Gents Quart ['jents-kwawrt] *n.* *GQ* magazine.

gifting [gift-ing] *v.* Getting free stuff from brands/agencies/etc.

goth ninja [goth-**nin**-j*uh*] *n./adj.* Those, not necessarily formally trained in martial arts, who favor a dark, drapey, and somewhat futuristic style of dress. The mortal enemy of the classic menswear enthusiast.

go-to-hell [goh-t*uh*-hel] *adj.* Obnoxiously loud-looking clothing. It's as if the wearer is telling everyone else to "go to hell" with what they are wearing.

grind [grahynd] *v.* The process of working toward your goals and dreams no matter how absurd and unlikely they are. Most commonly used by those with absurd and unlikely goals and dreams.

— H —

having a moment [hav-ing-ey-**moh**-m*uh*'nt] *adj.* Refers to something as it is gaining popularity. A tipping point.

herb [hurb] *n.* A lame person. A loser.

hem [hem] *v.* The process of shortening a garment.

homme [awm] *n. French.* *Man* as in "men's clothing." Sometimes used in the form "no homme-o," derived from the popular rap phrase "no homo."

honeycombs [**huhn**-ee-kohmz] *n.* Named after the pattern it resembles. Distinct fading that forms behind the knees of raw denim after continuous wear.

honeycombs (*n.*)

— I —

inbox [**in**-boks] *n.* Your email inbox. Used cryptically between people to indicate a behind-the-scenes conversation taking place over email.

inspiration folder [in-sp*uh*-**rey**-sh*uh*'n-**fohl**-der] *n.* An ever-expanding cache (usually digital) used to house items (usually images) that inspire.

instacop [in-st*uh*-kop] *adj.* Something so amazing that it has to be purchased right then and there.

— J —

jawnz ['jawnz] *n.* Clothing. "I need to double check my jawnz allowance for this month."

— K —

kit [kit] *n.* Like *fit*, the totality of your outfit.

— L —

lean [leen] *n.* A drinkable mixture of promethazine with codeine, Sprite, and Jolly Ranchers or the popular blog *A Continuous Lean.*

lookbook [loo'k-boo'k] *n.* A collection of stylized images that showcases a designer's or a brand's collection. Often utilized by brands that do not invest in runway shows or presentations.

— M —

MTM [em-tee-em] *n.* Made-to-measure. Clothing that is made to fit you specifically.

Made in the USA [meyd-in-*th*'ee-yoo-es-ey] *adj.* The ultimate badge of honor for a heritage or Americana brand.

merchandising [**mur**-ch*uh*'n-dahy-zing] **n./v.** The art of displaying product, clothing, and otherwise to communicate a specific message or aesthetic.

mood board [mood-bohrd] *n.* A collection or collage of images (digital or physical) that when viewed as a whole communicates the themes and inspiration behind a project.

lean (*n.*)

— N —

next level [nekst-**lev**-*uh*'l] *adj.* Something so impressive that all previous iterations or entities are below it, as if they were existing "on a previous level."

NYFW [en-whay-ef-**duhb**-*uh*'l-yoo] *n.* New York Fashion Week. An attainable goal for fashion acolytes because it is cheaper to attend than the European fashion weeks.

— O —

OCBD [oh-see-bee-dee] *n.* Oxford cloth button-down.

on location [on-loh-**key**-sh*uh*'n] Shooting a lookbook/photoshoot/editorial at a particular destination. Think lavish estates, abandoned industrial parks, and exotic locales.

OG [oh-jee] *n./adj.* Original gangster. Used to describe something or someone that has been around for a while and is most likely an originator or original. "Glenn O'Brien is the biggest OG of them all."

on point [on-point] *adj.* Denotes that something is "quality" or "solid" or "makes sense" or is, simply, "cool."

— P —

patina [pah-**tee**-n*uh*] *n.* The aging or worn nature of an item due to years of use.

peasant [**pez**-*uh*'nt] *n.* A lower-class person, see *plebe*.

photog [**foh**-tog] *n.* A photographer.

Pitti [**pit**-ee] *n.* Pitti Immagine Uomo. A menswear trade show in Florence, Italy. The holy grail of trade shows featuring, arguably, the greatest collection of well-dressed men in the entire world.

plebe [pleeb] **n.** A lower-class person, see *peasant*.

point and shoot [point-*uh*'n-shoot] *n.* A cheap camera (not a DSLR) that you literally "point" at your subject and "shoot" your photograph.

pop up [pop-up] *n.* A temporary retail space that "pops up" for a short amount of time before it closes its doors.

PR blast [pee-ahr-blast] *n.* Emails to be deleted.

proxy [**prok**-see] *n./v.* Using the services of another person to buy you an item of clothing, often abroad.

OCBD (*n.*)

— R —

rare [rair] *adj.* Denotes something very "special."

raw denim [raw-**den**-*uh*'m] *n.* Denim that has not been washed or treated. The antithesis of "dad jeans." The preferred casual pant of menswear.

retail [**ree**-teyl] *n.* A price no self-respecting person pays.

retweet [**ree**-tweet] *v.* To repost someone else's tweet to your followers. In most cases, an endorsement.

robocop [roh-boh-kop] *v.* See *instacop.*

rollie [**roh**-lee] *n.* Rolex. Often without a tick-tock.

RRL [**duhb**-*uh*'l-ahr-el] *n.* A high-end division of Ralph Lauren that sells vintage-inspired clothing.

RTW [ahr-tee-**duhb**-*uh*'l-yoo] *n.* Ready-to-wear. Unlike bespoke, MTM, or couture clothing, ready-to-wear is, indeed, ready to be worn directly off of the rack.

rugged [**ruhg**-id] *adj.* A masculine adjective aimed at straight male consumers used to denote clothing or goods that have a rough-and-tumble aesthetic.

— S —

sample sale [**sam**-p*uh*'l-seyl] *n.* A sale of sample or unsold clothing at comparatively cheaper prices. While on a humble salary, the best way to dress well without living above your means.

selvedge [**sel**-vij] *n.* Fabric with a self edge. Most commonly used when talking about jeans not bought at a mall.

sourcing [**sohr**-sing] *v.* The act of seeking out materials to begin a project. Most often used when referring to fabrics, buttons, and trimmings.

stance [stans] *n. British.* Like both *fit* and *kit,* the totality of your outfit.

selvedge (*n.*)

steez [steez] *adj./n./v.* Literally, *style* plus *ease.* The epitome of personal style.

sprezz [sprez] *adj.* Shortened form of *sprezzatura,* an Italian word describing a casual nonchalance exhibited in how one wears their clothing.

S/S [spring-**suhm**-er] *n.* Spring/Summer, a season.

stacks [staks] *n.* Neatly arranged piles of money.

steelo [steel-o] *n.* Simply, *style.*

stuntin' [stuhnt-in] *v.* Showing off, in most cases, purposely.

stylist [**stahy**-list] *n.* Someone who creates outfits for a living. A crucial cog in the photoshoot/lookbook/editorial machine.

swag [swag] *adj./n./v.* Shortened form of *swagger*, but really the ultimate catchall phrase that can be used for anything in any situation.

— T —

trad [trad] *adj./n.* Short for *traditional*. Denotes a particularly boring style of dress popularized by old dudes with internet connections.

trending [trend-ing] *v.* Simply put, something is currently on trend or popular.

trill [tril] *adj.* In the classic sense, a combination of words *true* and *real*. Something badass to its very essence.

— U —

uomo [**woh**-moh] *n. Italian.* *Man* as in *men's clothing*. Sometimes used in the form "no uomo," derived from the popular rap phrase "no homo."

Uggs [uhgz] *n.* A hot girl you won't admit to dating cause she wears Uggs.

— V —

Vibrams [**vahy**-br*uh*'m] *n.* A particular brand of rubber soles. One popular version is their white wedge or "Cristy" sole seen on the boots of dudes whose pictures end up on the internet.

Vibrams (*n.*)

— W —

wealth [welth] *n.* Over-the-top luxury. Careless and irresponsible with one's expenses. A state of pure being.

whiskers [**hwis**-kerz] *n.* The fades that appear in the crotchal region of raw denim. They emit from one's dick like whiskers from a cat's nose.

WIWT [hwuht-ahy-wohr-t*uh*-**dey**] "What I Wore Today." Pictures of what, just as the name implies, someone wore on the day the picture was taken. This practice has spawned an entire subgenre of bloggers who range from dudes who own full-length mirrors to chicks with professional photographers on staff.

— X —

____ x ____ [____tahymz____] The mathematical equation for your basic collaboration. As more parties are added, the multipliers increase.

I flip scripts

When my blade trips

Vents dip

Twit clips

Post dope dick pics

Breasts blow open

Bloggers Googling my knit slips

TASTY TEA
COOL DOWN

トレーニング後はクールダウ
ンしていることは常に重要
です。あなたの強さを補充
するための良い熱いお茶を
楽しむことができます。一週
間前を熟考し、新しいビジ
ネスベンチャーにジャンプス
タートを得るために時間を
使用しています。

お茶は最高の味がす。

あなたが汗を
かいているとき熱い

IN THE STREETS

パンチトレーニングでは、健康を保つとあなたのウィットシャープ。戦いのために、あなたのスーツで良いタイムアウトを検索するための準備することができます。

URBAN MOUNTAINEERING

トータルワークアウトは、規律とフォーカスの良い取引をする必要があります。あなたは非常に初めに起動しなくても百に取得することはできません。あなたのトレーニングスケジュールを整理し、常に朝食を食べるようにしてください。究極のスタイルのボディを取得するには、別の繰り返しとトレーニングのテクニックを行う必要があります。ジムに行くことを心配しないでください、URBAN MOUNTAINEERNGは本当にあなたの体を完璧にする唯一の方法です。

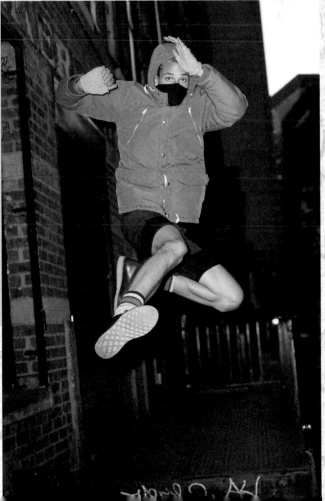

赤いひもで大きなオレンジ色のパーカーと靴のペアをポイントに、あなたのスタイルを保持します。決してスタイルのうち。決して形のうち。

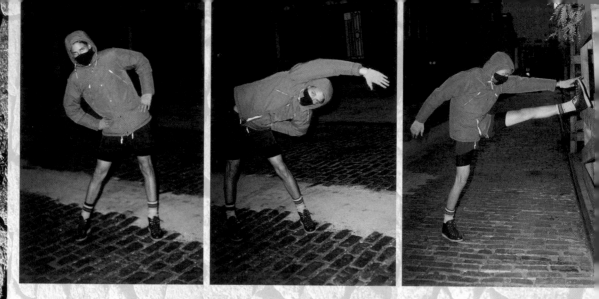

(STRETCHING IS IMPRESSING) ストレッチングは素晴らしいです。

GUIDELINES

あなた自身に時間を必要とする場合は、各朝はワークアウトしてみてください。それは緊張を解放し、自分の体を取得し、約キラー方法です。あなたの気分に応じてさまざまなトレーニングをしてみてください。都会の登山スタイルは、シャープ滞在に最適です。

CHAMPION LEGS!

脚の筋肉は、トーンとアクションの準備が整いました。

HOT KIT, HOT MUSCLES

ワークアウトすると、完全なスタイルに忠実な方法です。あなたの体はトーンとアクションの準備ができてください。

ランブルに準備します。

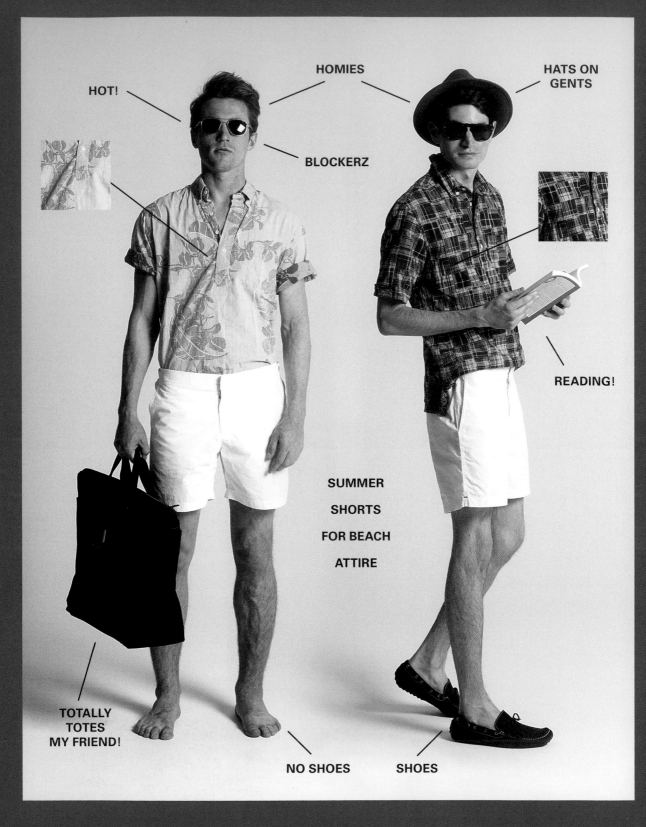

OFF DUTY BROS:
SHIPWRECKED HOMIES

CLASSIC

アーネストは、最高の髭のスタイルを持っていた。

ERNEST
HEMINGWAY

The Old Man and
the Sea

ハンディガイド

ビーチは忙しいニエから5までの男の最高のエスケープです。あなたが機会があれば、あなたの肺に海の空気を保持します。

BRING THE LITTLE GUY

男の最高の仲間。

BEACH ESSENCE
ALWAYS PACKED

トートバッグは、紳士のビーチスタイルを実現するための最良の方法です。あなたが持っていない場合は本土に滞在トートバッグ！

DRANK

氷冷島のドリンクを飲みながらクールダウン。

ビーチのライフスタイルへの鍵は常に正しい姿勢をしている。あなたは冒険の準備ができているスタイルは、砂の上に発生する可能性があります。あなたは正しいものを持っている場合。月にあなたの浜旅行をします。

CAPTAIN CHAMPION

カジュアルな頑丈な男の服

このセーラースタイルをチェックしてください。悪い見てはいけません。寒さのためか、ホットのため、常に暖かいご利用いただけます。

DETAIL

これらのリネンショーツだけでなく、冒険だけでなく、内部の屋外に最適です。下着の上にそれらを着用してください。

BIRKENSTOCK
あなたの疲れた老人の足に最適なシューズ。靴下や靴下なしでそれらを着用してください。あなたの快適ゾーンの都市を旅行。

LIEUTENANT FANCY

軍事的なスタイルは常に良い外観です。

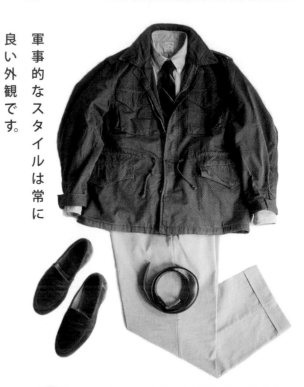

役員のスタイルは軍隊だけのものではありません。古い戦争からインスピレーションを取るとモダンな外観のために、あなたのスタイルを更新します。

あなたのウエストのまわりの小さな穴や金属片を持つアリゲーター革の部分をラップすることによって、あなたのズボンを保持します。一部の人々は、このベルトと呼ぶかもしれませんが、あなたはそれが実際に"スタイル"と呼ばれていることを知っています。

スエードの靴は、すべてのルマンクローゼットでなければなりません古典的なアイテムです。それらを身に着けるか、単に遠くからそれらを賞賛するためにそれらを取り出す。選択はあなた次第ですが、洗練された味を持っている場合は、賢明に選択します。

BLUE BLOOD DOGGY

古いお金のためのための紳士のお金のスタイル。

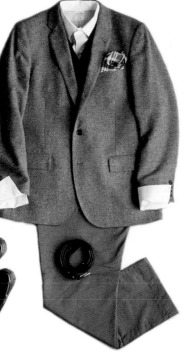

CLOSE UP

この驚くばかりの積層技術をチェックアウトします。あなたは良いレイヤーの重要性を理解していればあなたは真のマスターでしょう。

究極のスタイルのヒントのためにズボンのベルトをペアリングする。ベルトがどこに行くには、推測することはできますか?ベルトはベルトループを通過します。無汗!

ボートの靴は、しばしばカジュアルのいくつかの種類として見ています。しかし、それらはさまざまな方法を着用することができます。我々は彼らがズボンのこの赤ペアとペアになってくださいどのように見える。

HOT POCKET JUNIOR

ポケット広場といくつかの態度で鋭いご利用いただけます。

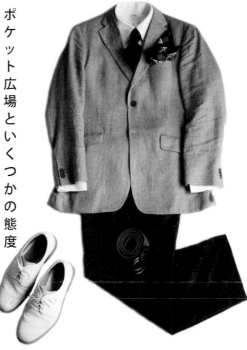

ニット関係は王と王子のためのものです。王子のように感じたいですか?ニットネクタイをつけて、あなたの友人の羨望の的になる。

リングベルトはそれをチェックアウトしてくるすべての女性をもたらします。それは本当のように簡単ではありませんでした保つ。

アイボリーホワイト。ええ、それはZordブロガーの同じ色です。ない捕虜を取らない、ラップの作家は、常にささやいています。

WHITE WHITES

■ 何度も老人は、ステップアウトゲートのが早すぎると若い男が彼に言う必要があります。ヘイ！あなたはそれを実行しないでください。あなたはクレイジーですか？あなたは最後の時間を覚えていますか？それはナンセンスだ

── PHOTO BOMB ──

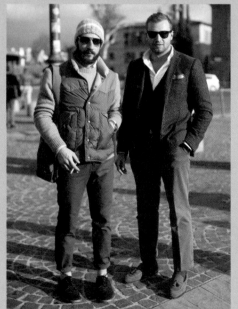

**CREAMY
SNACK
BREAK:
GELATO**

■ 何度も老人は、ステップアウトゲートのが早すぎると若い男が彼に言う必要があります。スだ

■ 何度も老人は、ステップアウトゲートのが早すぎると若い男が彼に言う必要があります。ヘイ！あなたはそれを実行しないでください。あなたは？それはナンセンスだ

HARD SHOES!

LIVING IN THAT
CITY STYLE!

最高の靴がどこにあるか。誰が
どんなものの我々はこの問題
を見ることが出来ますかを知
っている。それは実際にはあま
りにも多くのです最高の靴が
どこにあるか。誰がどんなもの
の我々はこの問題を見ること
が出来ますかを知っている。そ
れは実際にはあまりにも多く
のです。

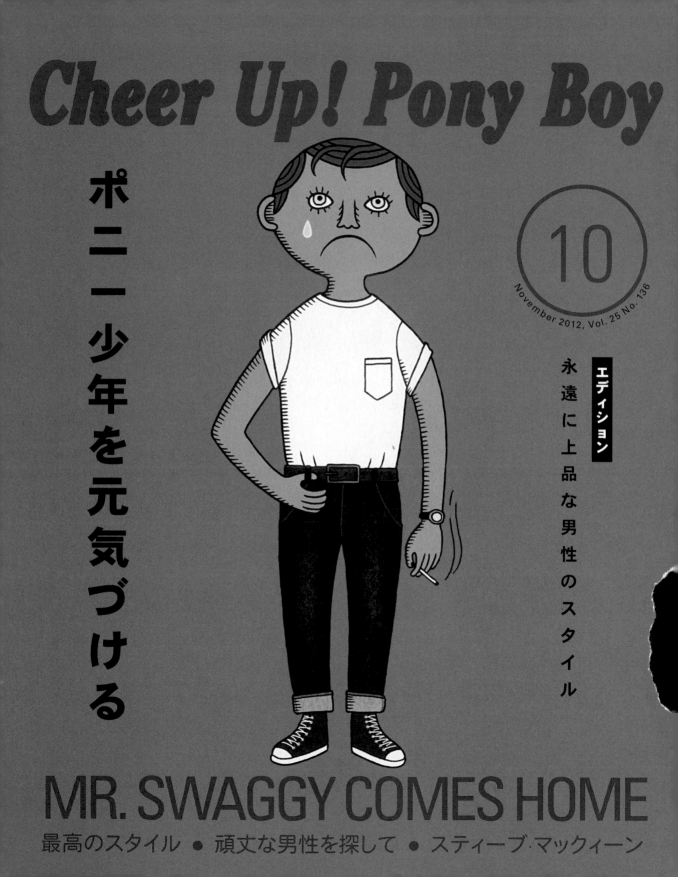